IMAGES
of America

INDEPENDENCE

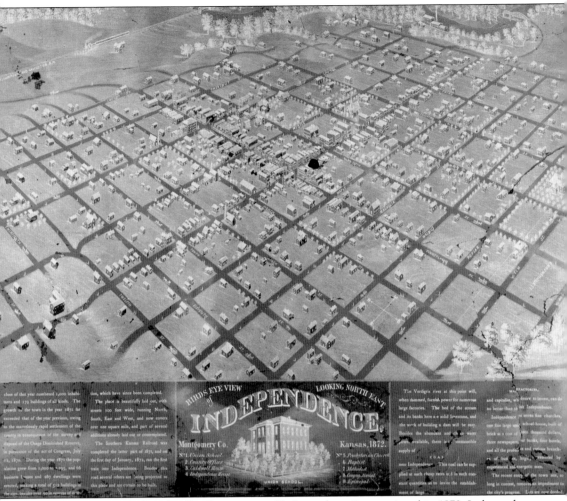

Just three years before this "bird's-eye view of Independence" was printed in 1872, Independence was given the nickname "Haytown" by bands of Osage Indians who traded with settlers in their crudely built homes with hay-covered roofs. Independence's spirit abounded in its infancy and took root quickly, as exemplified by the number of streets that were laid out in its early years. The commercial buildings congregated on the town's two largest thoroughfares, Pennsylvania Avenue and Main Street. Both roads lead to the nearby Elk and Verdigris Rivers. (Courtesy of Ned Stichman collection.)

ON THE COVER: Some of Independence's leading ladies donned flowery hats and festooned their buggy with flowers in an 1896 event that showcased themselves and their horse-drawn transportation. Pictured in front of the Montgomery County Courthouse are Ida E. Wood (left) and Katherine Whitman in the buggy and Anna Whitman on the white horse on the back cover.

IMAGES
of America

INDEPENDENCE

Andy Taylor

ARCADIA
PUBLISHING

Published by Arcadia Publishing
Charleston, South Carolina

Printed in the United States of America

Library of Congress Control Number: 2014934907

For all general information, please contact Arcadia Publishing:
Telephone 843-853-2070
Fax 843-853-0044
E-mail sales@arcadiapublishing.com
For customer service and orders:
Toll-Free 1-888-313-2665

Visit us on the Internet at www.arcadiapublishing.com

*To any person who purposefully or graciously put a camera
to their eye and saw a story of Independence unfold in
the viewfinder—this book is dedicated to you.*

CONTENTS

ACKNOWLEDGMENTS

Preparation for this book could not have been possible without the support and help of a handful of Independence residents who have carried with them the history of the community in their hearts . . . and in their photo albums.

Among those who loaned photographs for the preparation of this book were Ned Stichman, who carries an incredible knowledge of Riverside Park and the Ralph Mitchell Zoo, and Rick Knapp, whose numerous albums containing pictures and postcards from Independence's past decades were extremely helpful.

Numerous others also loaned photographs for this book, including the staff of Westar Energy, the staff of the Independence Public Library, and, of course, the staff and volunteers at the Independence Historical Museum and Art Center, who graciously opened all doors and files so that the silent images from the past could gain a new voice. All images in this work appear courtesy of the Independence Historical Museum and Art Center unless otherwise noted.

Two people stand out for their devotion to preserving the history of Independence. John Koschin has spent his retirement years collecting artifacts and photographs of everything about Independence. His hunt for photographs makes him a detective, but his zeal for collecting fantastic images from the past makes him an artist. He already has produced several books about Independence's history, but his fingerprints can be seen throughout the files and archives of the Independence Historical Museum and the Independence Public Library.

The same is true for Ken Brown, the retired Independence Community College instructor who has an obsession about local history, specifically the older homes that give Independence its distinct charm. Like Koschin, Brown has produced several books about the city, and he is regarded as the supreme historian for all things Independence.

Years from now, when a new generation of Independence natives decide to go back into the yellowing archives of yesterday and today to see what life was like, they will thank the vast supply of materials collected and preserved by John Koschin and Ken Brown. If Independence was located in England, these two men would be deserving of knighthood.

Finally, this author's wife, Amy Taylor, and daughter, Lillie Taylor, were gracious and patient while the author spent numerous weeknights and weekends away from the family home. No one can ever understand that unconditional love. And, for that, this author is truly a blessed man and is forever grateful to live in Independence, Kansas.

INTRODUCTION

Upon opening a photo album from Independence's past, one likely finds a recurring theme in the fading images: celebration. Independence likes to party. The old photographs captured it, and the town's legacy still bears it.

Independence is known far and wide for its festivals, parades, and celebrations. It is likely that almost every home in Independence has a gallery of photographs chronicling some sort of celebration: Neewollah parades, Riverside Park festivals, homecoming pageantry, or school and college activities.

Perhaps the concept of celebration was born in the town's infancy, some eight years after the conclusion of the Civil War. A group of men from Oswego, in Labette County, finding a hay-strewn meadow near the Verdigris River as a fitting place to set up shop, liked what they saw. To celebrate the town's humble beginnings, the settlers fetched a fatted ox, a whole barrel of bread, and four kegs of beer from their former Oswego home and made the long journey back to Independence. However, in trying to cross the turbulent waters of the Verdigris River, east of Independence, the wholesome fare tumbled from the horse-drawn wagon. "A hasty attempt was made to recover them, and the main part, including the beer, was soon fished out from the river," according to an account from William Cutler's 1883 *History of the State of Kansas*. "And the party went on their way rejoicing."

Whether the breaking of the town's first bread set the stage for future parties is unknown; however, events of the first year quickly solidified Independence's place in southeast Kansas. When an election was held in November 1869 to name the county seat of newly formed Montgomery County, Independence threw its hat into the ring despite strong efforts by the village of Liberty to land the county courthouse. Liberty won the election, but not without a fight from Independence forces, who took their cause to the nearest court in neighboring Wilson County to protest the election. The now-defunct town of Verdigris City was delegated the initial county seat until the election could settle the matter. Verdigris City residents hoped to retain the prestigious title of county seat, making the fight for it a three-way contest.

The dispute went to Topeka, and the highest levels of state government, where a new election was ordered. From that second election one year later, Independence gained the majority votes (839) over its rival Liberty (279). Independence, by virtue of that election, would gain the county courthouse and title as king of the county.

Also in 1870, Independence saw the last traces of its earliest residents, the Osage Indians. By virtue of the Drum Creek Treaty, signed at the confluence of Drum Creek and the Verdigris River, three miles southeast of Independence on September 10, 1870, the Osage Indians agreed to hand over its last remaining lands in Montgomery County in exchange for land in Indian Territory.

In the mid- to late 1860s, the Osages were on the move as treaties pared their lands in Kansas. Numerous villages lined the banks of the Verdigris and Elk Rivers, and Indian trails crisscrossed the county as a sort of primitive highway of commerce and culture. Those same Osages had traded with the several dozen white settlers who gathered prairie hay and sod to form a collection of crude buildings in an area that the Osage would call "Haytown." That was the first name applied to the site that would become Independence.

The new settlers, though, had little use for their crude surroundings, their nickname, or the Indians who camped along the rivers and creeks. For better or worse, settlers appealed for the removal of the Osage in an attempt to open more lands for settlement in Independence and Montgomery County. When the ink had dried on the Drum Creek Treaty of 1870, the Osage were left with no other option but to fold their buckskins and migrate to their new home in Indian Territory.

Several decades after moving to Indian Territory, those same Osage Indians discovered that under their new lands sat one of the largest underground pools of crude oil in the world. Within 30 years of removal to Indian Territory, the Osage tribe became among the wealthiest nations on the planet.

In early Independence, growth was taking place at a hastened pace. Several sawmills were quickly erected to take advantage of the construction trade that was necessary to raze the hay-covered homes and replace them with wooden structures. With the first buildings erected, downtown Independence resembled a town in an episode of *Gunsmoke*. Clapboard buildings and wooden sidewalks lined the main thoroughfares of Pennsylvania Avenue and Main Street. Hitching posts were the norm, and the dust kicked up by horses and wagons left a film of chapped dirt on the smiling faces of the rugged settlers and builders. Standing out amid the stick-built structures was an impressive two-story brick building erected in 1870 as the first masonry building in Independence, Montgomery County, and the southern tier of counties. That building, the first courthouse of Montgomery County, served as the central point of activity in Independence.

Those dusty smiles would turn sour, though, when a series of fires between 1875 and 1885 destroyed the first vestiges of Independence. City officials quickly passed an ordinance calling for all commercial buildings to be constructed of brick or stone as a way to stave off the ornery spark whenever it befell tender-dry wood.

And, build they did. No edifice exemplified the strength and character of early Independence as did the new Montgomery County Courthouse, which was constructed on the town's highest rise, on Main Street, between Fifth and Sixth Streets. When the cornerstone was laid, with a ceremony led by the local Masonic Lodge on November 30, 1886, hundreds of residents from Montgomery County gathered at the site to place mementoes and artifacts in a time capsule. It was ultimately sealed and placed in the new courthouse's corner. Following the local coronet band's performance of "Nearer, My God To Thee," the cover was placed on the cornerstone, and the time capsule was sealed as a reminder of the city's and county's earliest history. Numerous speeches were given, and representatives from each township were asked to provide a history of their region.

Following a prayer and a threefold "Amen," the townspeople partied, complete with an all-day feast and dance at the local opera house, according to news accounts of the cornerstone ceremony.

The "new" courthouse stood almost 126 feet in height and could be seen from every corner of Independence. It was designed with a French Gothic appearance and constructed with a clock tower and a statue of justice standing sentry over the main entrance.

Other major construction projects in Independence in the 1880s and 1890s included a water plant (1884), Montgomery County High School (1897), an electric plant (1893), and a gas plant (1895). Independence's boom would not reach its apex until gas and oil were discovered shortly after the turn of the century. In 1902, just as these resources were being sniffed out of the earth, Independence's population was 6,208. By 1907, the population exploded to 15,335.

Independence was at the epicenter of the new capital of the midcontinent oil and gas fields, and the citizenry quickly discarded its hayseed ways for upscale, progressive paths. The construction of houses and commercial buildings focused on opulence and design, illustrating the power of wealth. A walk down Pennsylvania Avenue in 1912 was a far cry from 30 years prior, when dirt covered every surface. Multiple-story buildings lined the brick streets, where gaslights freely provided illumination and where the country's newest novelties, including the moving motion picture, the trolley system, and the elevator, were the latest technological marvels. Gone were the days when dry-goods stores sold simple canvas sheets. By 1907, millinery stores in downtown

Independence brought the latest fashions from Parisian and Eastern designers. A souvenir issue of *Independence Weekly Times* in 1907 described the city:

> Look up the main streets of Independence this Saturday night; and observe how they are thronged with well dressed people from all the walks of life; see those streets lined with two and three-story brick blocks, bright with gas and electric lights, and here and there flaming out with rhythmic signs, and you will agree that a real city is growing up here in this marvelous section. Or wait until the morrow and ride over our paved streets and note the hundreds of modern residences and comfortable homes from which the crowds are wending their ways to our churches and Sunday schools, and you will further agree that the material wealth that is being multiplied here with such bewildering rapidity is not entirely dwarfing our spiritual natures or leading us to forget that there is nothing a man can afford to take in exchange for his soul.

And, so, the earliest decades of Independence gave rise to a new era of unprecedented growth. Cement manufacturers, brickyards, refineries, asphalt and rubber plants, grain elevators, and smelters would crowd into Independence and deliver a community that was among the fastest-growing cities in Kansas. The words "Made in Independence, Kansas" would be stamped on everything from cigars to revolving doors. Money poured into the community. Mansions were built at a steady rate. By 1915, Independence held the claim to having more millionaires per capita than any city in the United States.

Proof in Independence's profound industrial influence came in 1905, when it became the global headquarters to an upstart company called the Prairie Oil & Gas Company. The oil and gas boom over the years led to the company's decision to build a six-story skyscraper between Ninth and Tenth Streets and Myrtle and Laurel Streets. The vast structure would be the town's most identifiable icon, even in subsequent years, when it would be purchased by the Sinclair Oil and Refining Corporation (named after Harry Sinclair) and later by Atlantic Richfield Pipeline Company.

And, whenever the town erected a new building and promoted a new cause, the residents celebrated. Even in 1919, when a group of local men worried that Halloween had become too much of an incentive for young hooligans, they threw an easygoing parade as an alternative to the rabble-rousers. What they did not know was that that first Halloween parade would take on a life of its own. In Independence, each and every Halloween thereafter would be synonymous with parades and festivities.

The Neewollah Festival ("Halloween" spelled backwards) remains a cultural celebration not just for the community but for the entire region. Even in the 21st century, the festival is the largest annual event in Kansas, complete with multiple parades, a Broadway musical, a queen pageant, and numerous activities that lend Independence a party atmosphere.

While the oil and gas interests subsided over the years, industrial development remained a hallmark of Independence. Looking for a way to revive the city's tired ways, a group of local officials successfully lobbied a Kansas-based aviation manufacturer to locate a new plant here. Just days before Christmas in 1994, Independence was offered one of its biggest holiday gifts with the announcement from Cessna Aircraft Company that it would bring its new single-engine aircraft assembly plant to Independence, giving the city the title of "light aircraft capital of the world."

Flying above the greenish prairie grass that once saw rugged pioneers with only a satchel and a dream . . . gliding above the wooded areas and creeks where Osage Indians once scouted whitetail deer . . . buzzing the clouds above the streets that have echoed with generations of parades and celebrations . . . is the newest chapter of Independence's history.

However, there is something that unites the pioneers with the modern-day pilot—a desire to kick back and celebrate all-American values. For much like when that rickety wagon brought beer, beef, and bread to Independence in 1869, the city will celebrate in similar fashion next year, and the year after.

That is a guarantee.

The photographs prove it.

One

EARLY YEARS

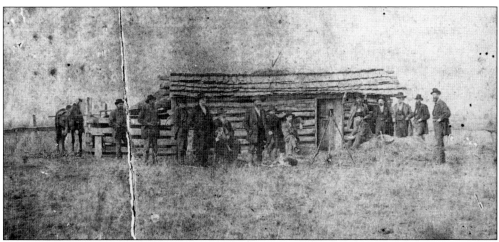

What is believed to be the first dwelling in Independence was given the nickname "Bunker's Cabin" after its owner, pioneer Frank Bunker. The crudely built log-and-hay cabin was erected in 1869 on the location of the present-day Losey Gymnasium at Tenth and Pine Streets. This photograph is thought to have been taken about 1870. (Courtesy of Independence Public Library collection.)

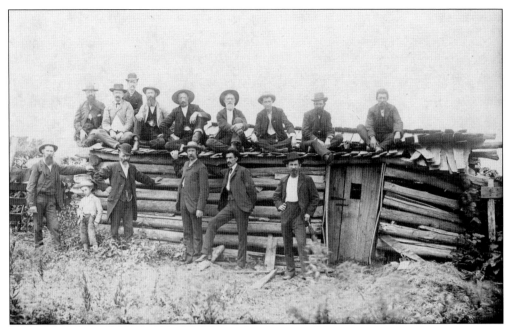

Although Bunker's Cabin appears to be on its last legs, it still has enough strength to support the weight of nine adult men. This 1880 photograph was taken upon the visitation of Fred Bunker, Frank Bunker's brother from Boston, Massachusetts. Pictured from left to right are (standing) J.H. Pugh and his son Robert, James Concannon, O.P. Gamble, H.W. Conrad, and Geo. C. Ernsberger; (sitting on the roof) Dr. B.F. Masterman, Starr Stephenson, L.T. Stephenson, W.H. Hays, Dr. R.S. Heady, John McCullaugh, E.E. Wilson, Fred Bunker, and Frank Bunker. (Courtesy of Independence Public Library collection.)

Independence was nicknamed "Haytown" in its earliest days—and for good reason. Abundant prairie hay and native grass attracted farmers and stockmen to the area, as indicated in this 1880s-era photograph; however, Haytown did not appeal to all people. "In October of 1869, some fly-by-nites started a village called Haytown several miles south of us. They gave it the high-toned name of Independence, but it won't last long," wrote settler D.C. Krone to a friend named Charley in a letter penned March 17, 1870.

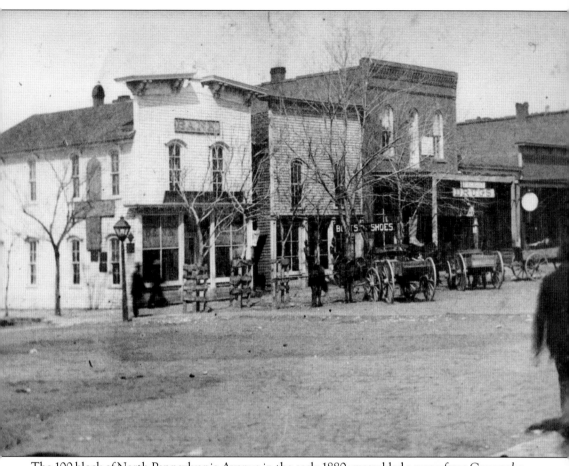

The 100 block of North Pennsylvania Avenue in the early 1880s resembled a scene from *Gunsmoke*, with clapboard buildings, boardwalk sidewalks, hitching rails, and a dirt street. This photograph shows the west side of the block. The lamppost in front of the bank is at the corner of present-day Pennsylvania Avenue and Main Street. "Independence in her youth was an example of enterprise which could be emulated in her maturer years," wrote Ebenezer E. Wilson in his 1881 book *Historical Atlas of Montgomery County, Kansas*. "The first item contributing to success was the selection of a full section of land for a site, and the platting on a magnificent scale, with broad streets and avenues, public grounds and etc. From the spring of 1871 to that of 1872, two hundred houses were erected, and the population swelled from one thousand to twenty-three hundred. This was during the lot jumping era, when the title of the Town Company was ignored, and houses were built on wheels and at night moved on to some vacant lot and occupied."

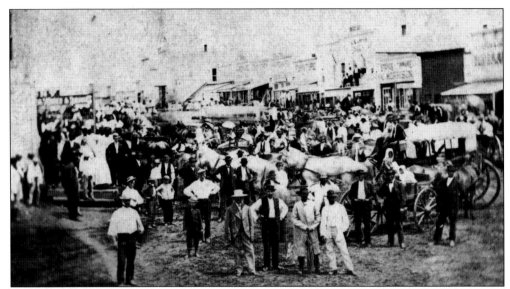

Cowboys and city slickers alike gather for a rare photograph at Independence's main point of commerce, Pennsylvania Avenue and Main Street, in the 1870s. Note the citizens standing atop the wooden awning and hanging from the second-floor window in the building in the background.

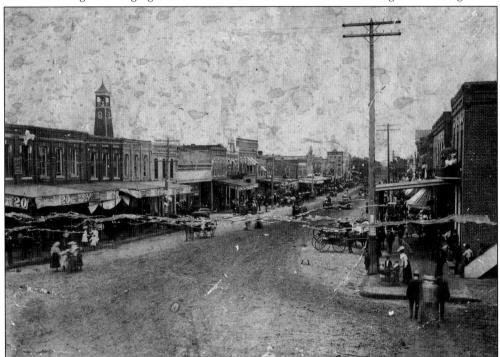

The dirt surface on Pennsylvania Avenue is freshly graded for a community event in this 1880s photograph. Signs touting an upcoming performance of the Great Wallace Show, which was the second-largest circus in the United States at the time, were placed on downtown buildings. Note the dirt paths worn by pedestrians as they crossed Pennsylvania Avenue to the south. This view faces southeast from the intersection of Pennsylvania Avenue and Laurel Street. (Courtesy of Ken Brown collection.)

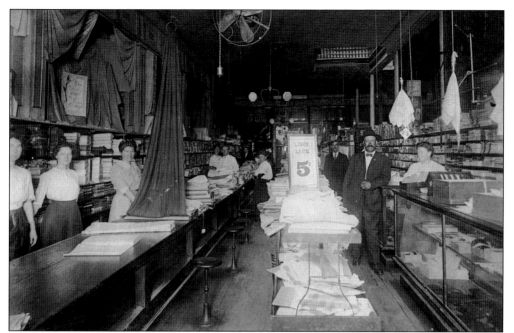

Baden Dry Goods was a staple of commerce in downtown Independence since its inception in 1870. Founder Henry Baden created the dry-goods trade in his downtown shop, but he expanded the company to include a wholesale business, particularly in groceries. In 1907, the Baden companies employed more than 50 people. He also was owner of the Baden Clothing Company, located at the prime intersection of Pennsylvania Avenue and Main Street. (Courtesy of Harold Baden collection.)

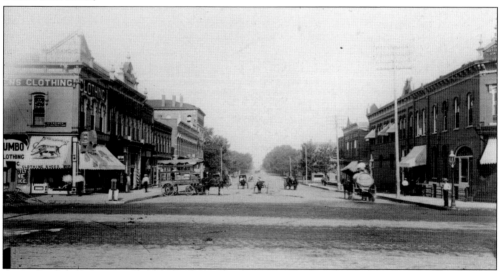

In the days before brick and asphalt streets, horse-drawn sprayers had to be used to apply water or oil in an attempt to hold down dust on the dirt-covered streets. This photograph, taken before 1900, shows a sprayer in action on the north side of Main Street west of the intersection with Pennsylvania Avenue. As seen here, horse-drawn buggies could be piloted four or five across on Main Street. The Independence Transfer & Storage Company taxi loads freight from a clothing store on the south (left) side of Main Street. (Courtesy of John Koschin collection.)

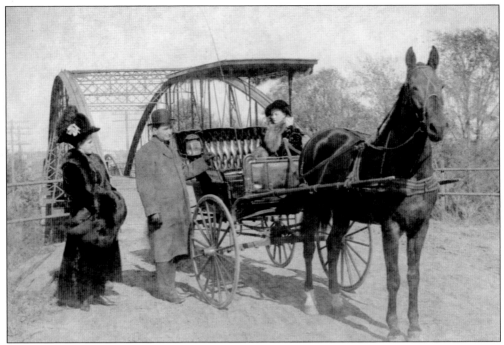

Dressed in their furs and wool coats, this Independence family shows off their horse-drawn surrey in front of the Verdigris River bridge. The photograph was lifted from a glass negative.

Before bridges spanned the Verdigris River, residents had to wait for low water at Brown's Ford, located south of Independence, in order to cross the river. This c. 1890 photograph includes, from left to right, Hannah Scott, Hugh Scott, Jennie Bailey, Elizabeth Woodruff, Jim Scott, and Kate Starr. (Courtesy of the Woodruff collection at Pittsburg State University, Axe Library special collections.)

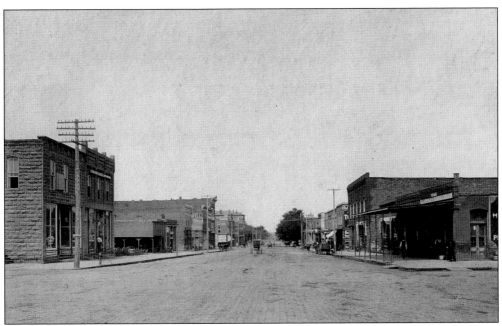

The progress of transforming Independence from a cow town to a progressive, turn-of-the-century community can be seen in the wide brick streets and two-story masonry buildings. This photograph shows Main Street looking west from the intersection of Sixth Street. Notice the town's newest safety feature—a fire hydrant—located to the right of the utility pole on the left side of the street.

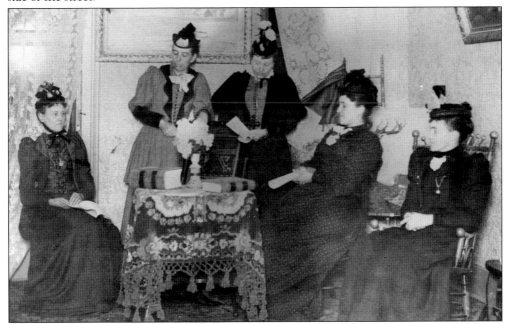

Wearing the finest hats and dresses that the 1890s could offer, the officers of the Independence Library Association gather for a photograph in 1895. They are, from left to right, Mrs. H.D. Grant, Mrs. J.E. Pugh, Mrs. J.B. Ziegler, Mrs. Edwin Foster, and Mrs. W.P. Bowen. (Courtesy of the Independence Public Library collection.)

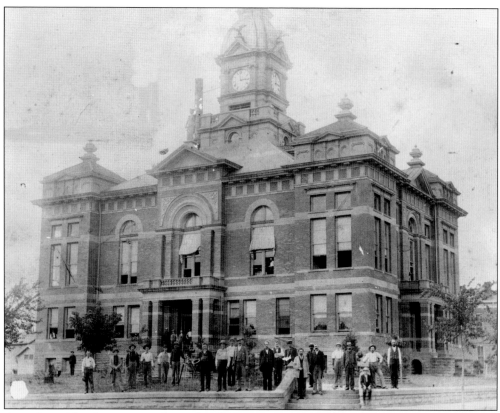

As indicated by the open windows, the afternoon was warm when this photograph was taken on the south side of the Montgomery County Courthouse property. Courthouse employees peer through the open windows. An individual standing in front of the main entrance is holding a surveyor's instrument. (Courtesy of John Koschin collection.)

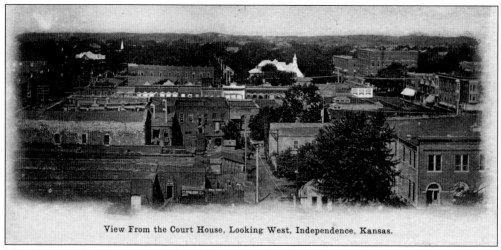

View From the Court House, Looking West, Independence, Kansas.

This photograph of downtown Independence was taken from the upper floors of the Montgomery County Courthouse looking west. The Carl-Leon Hotel is visible in the upper-right corner. The white church spire to the left of the Carl-Leon Hotel is the Congregational Church. (Courtesy of Rick Knapp collection.)

This pre-1900 photograph of the Independence Police Department shows the constables in their bobby-style helmets.

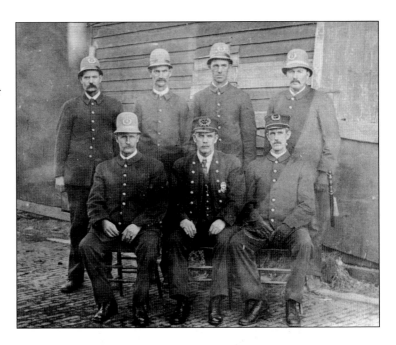

Independence's closest neighbor was the town of LeHunt, which was located at the base of Table Mound some three miles northwest of Independence. A company town, LeHunt was the headquarters for the Kansas Portland Cement Company. All community activity centered on the cement plant, and the small village of LeHunt sprouted in the shadows of the plant's massive buildings. The small houses in the background stand in contrast to the size of the cement plant's structures.

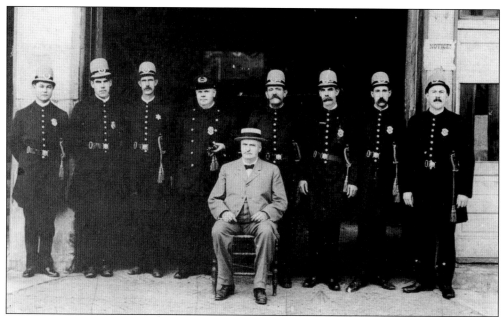

Members of the Independence Police Department pose with Mayor A.C. Stich (seated) in this 1910-era photograph.

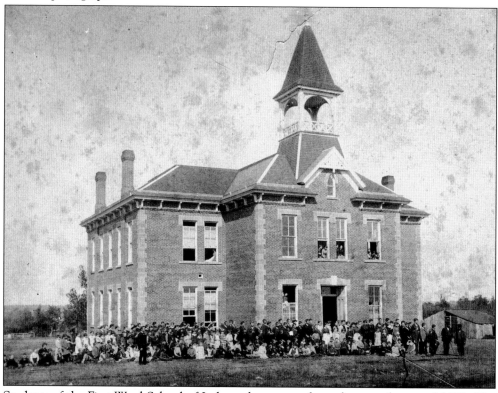

Students of the First Ward School of Independence pose for a photograph around 1900. The First Ward School was located at Fifth and Myrtle Streets. This photograph was lifted from a glass negative.

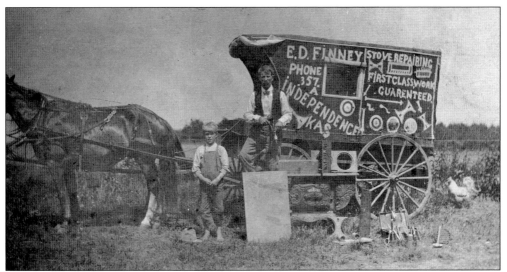

E.D. Finney of Independence promoted his services and wares aboard a horse-drawn wagon when this photograph was taken, presumably before 1900. The signs on the wagon read, "E.D. Finney, Phone 357, Independence, Kas. Stove Repairing. First class work guarenteed [*sic*]." Note the small trunk of hand tools on display in front of the wagon wheel. (Courtesy of *Montgomery County Chronicle* archives.)

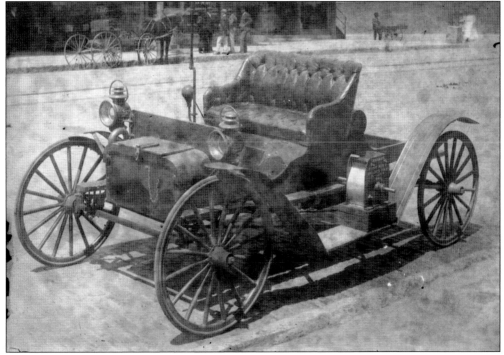

An unusual sight on Pennsylvania Avenue around 1905 was the horseless carriage. This photograph, taken from a glass negative, shows one of the first automobiles to arrive in the community. Note the horse and buggy across the street. A group of people converses in the background, unaware that the presence of gas-powered vehicles would transform their lives. The photograph was taken at the 200 block of North Pennsylvania Avenue. Laurel Street is in the top-right corner.

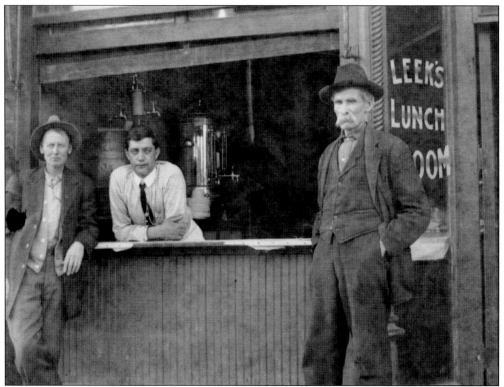

Customers and an employee of Leek's Lunch Room in downtown Independence pause for this c. 1900 photograph, which was lifted from a glass negative.

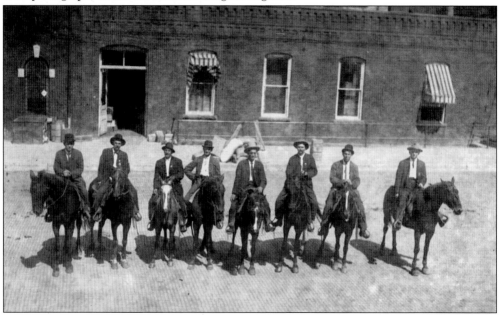

It is unknown where this posse of law enforcement officers was headed when it was photographed in downtown Independence sometime before 1910; however, it appears that the men meant business. This photograph was lifted from a glass negative.

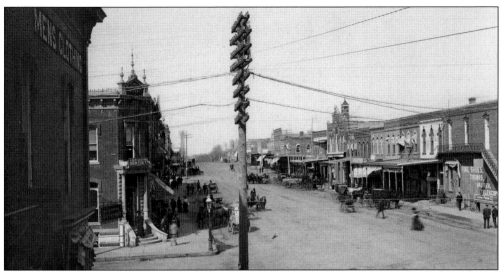

What was the chief sign of progress in Independence's transition from secluded town to outwardly growing community? As seen here in 1904, it may have been the recently installed telephone and electricity infrastructure in downtown Independence. A maze and mass of wires, utility poles, and couplers connected businesses with the outside world and brought modern conveniences to the establishments. This photograph of Pennsylvania Avenue was taken from south of the intersection with Main Street. Note the gaslight lamp in front of First National Bank. (Courtesy of John Koschin collection.)

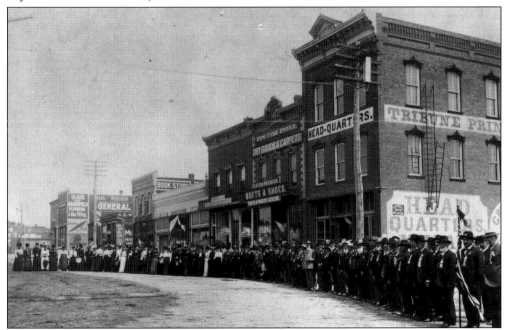

A delegation of Civil War veterans gathered for a reunion of the Grand Army of the Republic when it met in Independence. At this time, dirt streets were the norm. This photograph was taken at the intersection of Pennsylvania Avenue and Main Street looking toward the southeast. The south side of the 100 block of East Main Street, with the Tribune Printing office as the tallest building on the block, is depicted here.

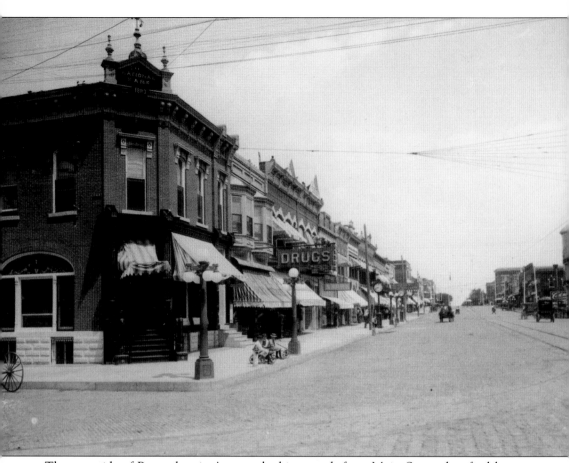

The west side of Pennsylvania Avenue, looking north from Main Street, has freshly swept sidewalks and clean streets. The brick street surface ridded the downtown area of dirt streets. The First National Bank building, constructed in 1883, served as the architectural anchor of the 100 block of Pennsylvania Avenue for many years. Note the three children sitting on wagons and the multiple-globe streetlamps that line the avenue.

Two

CHALLENGES
AND TRIUMPHS

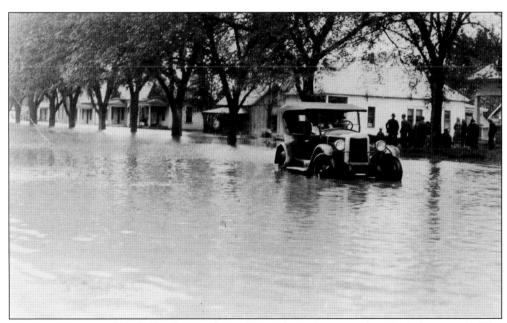

A car navigates axel-high floodwaters from the Verdigris River in this 1920 photograph. The exact location is unknown. (Courtesy of Westar Energy collection.)

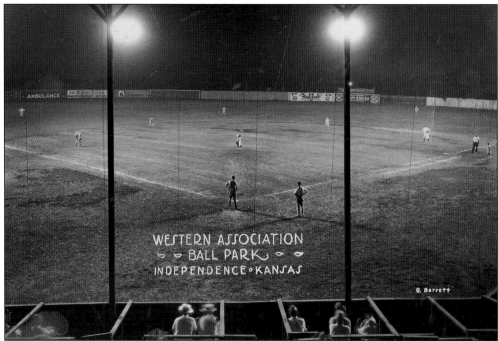

Independence's Riverside Park baseball stadium shone brightly in 1930, a season that introduced nighttime baseball to professional sports. The first recorded night game in organized baseball occurred at the stadium on April 28, 1930, when the Independence Producers of the Class C Western Association hosted a team from Muskogee, Oklahoma. The Muskogee team won the game 13-3, but the real winner was Independence, a trendsetter in the world of nighttime professional sports. (Courtesy of Rick Knapp collection.)

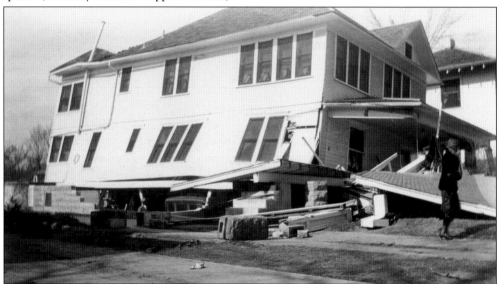

A freak winter tornado tore through Independence on Sunday evening, February 24, 1935, damaging numerous homes in the southern and eastern neighborhoods. This home at 409 South Fifth Street sustained serious damage after it was uprooted from its foundation, exposing the basement garage (notice the car in the basement). (Courtesy of John Koschin collection.)

Floodwaters from the Verdigris River engulfed this Kansas Gas & Electric Company substation on the eastern outskirts of Independence on May 20, 1943. The waters reached a peak three feet higher than what is shown in this photograph. (Courtesy of Westar Energy collection.)

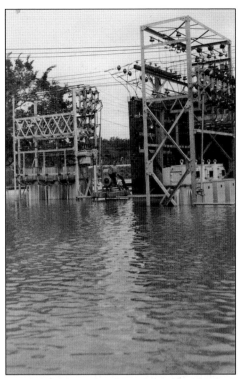

Present-day US 160, east of Independence, was under construction in 1961 when the bloated Verdigris River overwhelmed its banks. The US 160 highway bridge, under construction, is visible immediately to the left of the quadruple-arch bridge. The extent of the flood is visible in the eastern Independence neighborhoods at the top of this aerial photograph, which is facing west-southwest toward Independence. The 1961 Verdigris River flood is the fourth largest on record in Independence, according to the National Weather Service.

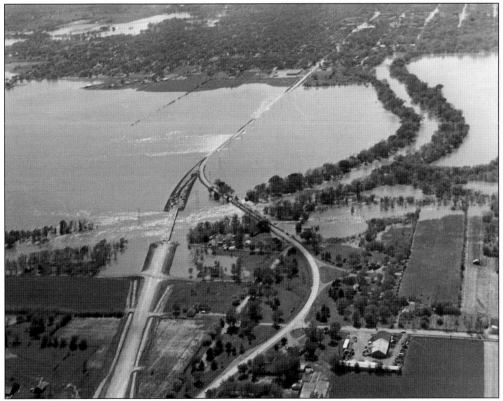

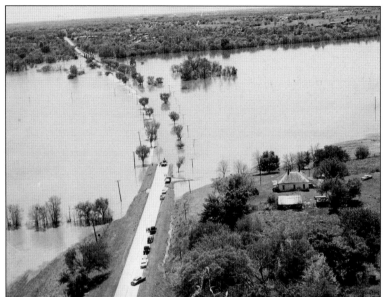

In 1961, the engorged Elk River spilled over its banks and impaired motorists on US 75 north of Independence. This aerial photograph, looking south toward the city, shows stranded motorists at the end of the floodwaters. The triple-arch Elk River bridge is visible in the background.

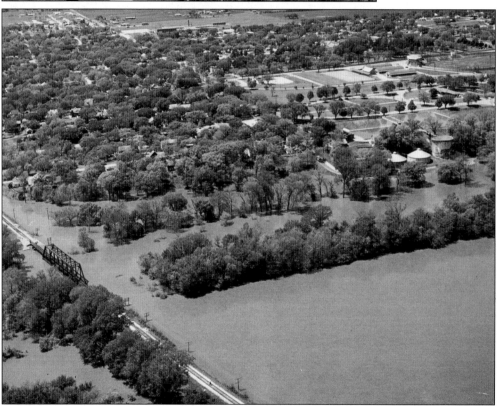

The Verdigris River flexed its muscle in a 1962 flood that spread waters through the eastern side of Independence. This aerial photograph, facing northwest, shows Riverside Park in the top-right corner. The Atchison, Topeka & Santa Fe Railroad is visible in the lower-left corner. Note the person walking in the middle of the railroad tracks in order to avoid the floodwaters on both sides of the tracks.

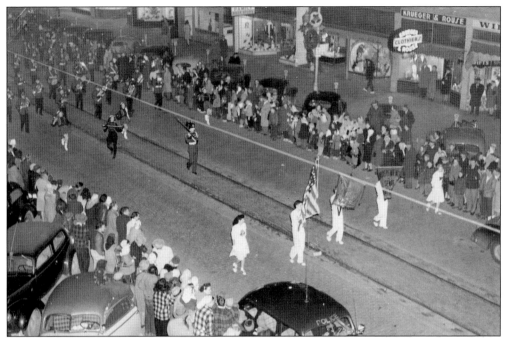

When the Kansas Gas and Electric Company installed new streetlights in downtown Independence in 1948, residents celebrated in the way they knew best: a parade. The Independence High School band led the parade, which coincided with the Christmas shopping season, on December 4, 1948. (Courtesy of Westar Energy archive collection.)

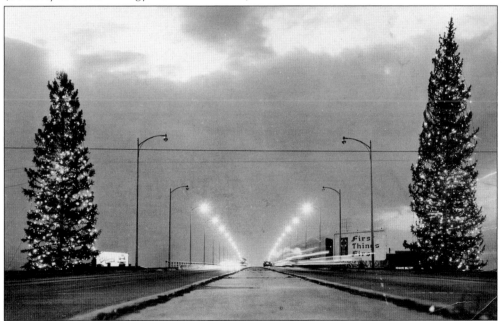

Illuminated Christmas trees greeted motorists when they arrived in Independence on US 160, or West Main Street, from the highway overpass. Billboards stand on each side of the street, one advertising Pabst Blue Ribbon beer and the other promoting a church with its motto, "First Things First." (Courtesy of Westar Energy archive collection.)

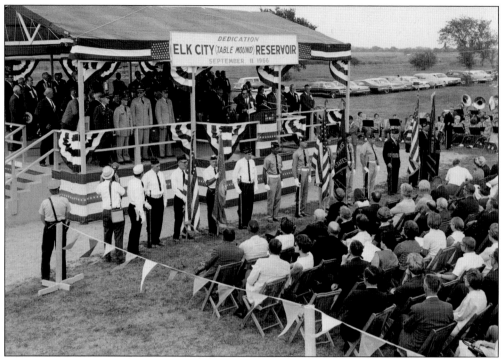

Members of the Independence American Legion Post, Veterans of Foreign Wars, and the Independence High School and Independence Community College bands were among the parties that helped with the dedication ceremony of the Elk City Reservoir on September 11, 1966.

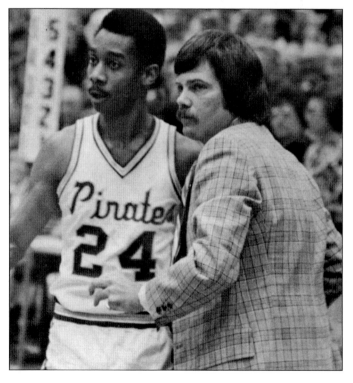

The 1976–1977 basketball season at Independence Community Junior College (ICJC) was the most successful in the school's history. The team, led by coach Dan Wall, won the National Junior College Athletic Association (NJCAA) tournament in Hutchinson, Kansas. The Pirates defeated the San Jacinto Ravens 75-72 in the national championship game on March 19, 1977. Seen in the 1977 ICJC *Communico* yearbook, Wall (right), with Garry Chushinberry, was named the outstanding coach of the NJCAA tournament. (Courtesy Independence Public Library collection.)

ICJC player Leslie McLeod (22) knocks over a Northeastern Oklahoma A&M defender in a home basketball game during the 1976–1977 season. McLeod, pictured in the 1977 ICJC *Communico* yearbook, finished the national championship season at ICJC with 190 points, 178 rebounds, 15 assists, and 12 steals. (Courtesy Independence Public Library collection.)

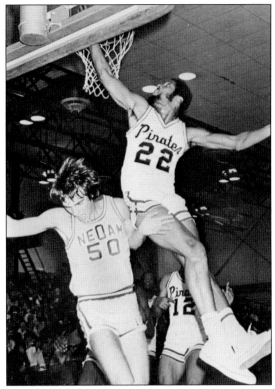

Members of the Independence Community Junior College pom-pom squad are seen in a photograph from the 1982–1983 yearbook. They are displaying their uniforms, which included knee-high socks and oxford shoes.

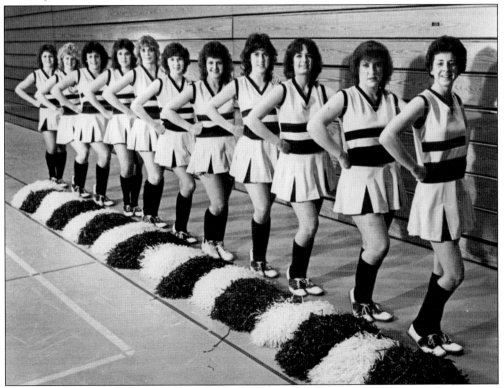

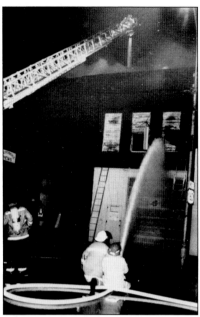

Firefighters from the Independence Fire Department battle flames and smoke in a 1994 fire that destroyed buildings on the 200 block of West Main Street. Consumed in the fire were the offices of the *Independence News*, owned by John F. Vermillion. A portion of the Gold & Silver Pawn Shop was also damaged in the blaze. (Courtesy of the *Montgomery County Chronicle* archives.)

West Main Street was still largely a rural setting when this north-facing photograph was taken in the mid-1970s. Peter Pan Road extends to the north from the center left of the image. The large, flat-roofed building in the lower-right corner was the original Kmart store, which is the present-day Independence Community College West Campus. The footprint of the former Sunrise Drive-In Theatre is visible at the corner of West Main Street and Peter Pan Road. (Courtesy of Westar Energy collection.)

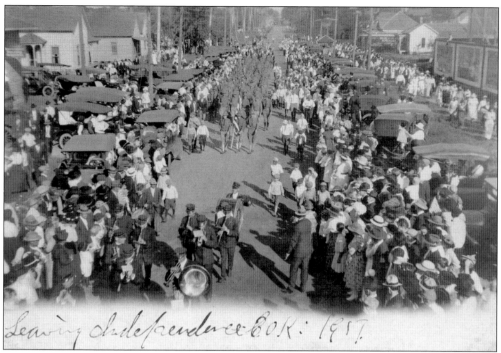

Leaving Independence Ko: 1917

In 1917, members of Company K of the Kansas National Guard march toward the Santa Fe Railroad depot, where they would depart for battle in World War I. A local band leads the parade of soldiers, while thousands of people line the street or have joined the procession on the sidewalks. (Courtesy of Rick Knapp collection.)

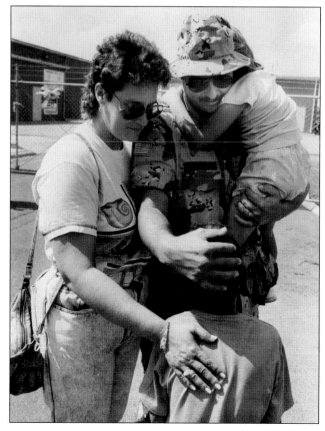

Sgt. Daniel Eck, a member of the Independence-based 1011th Quartermaster Company of the US Army Reserves, receives a tight embrace from daughter LouCinda while he and his wife, Barbara, hug their son John upon the company's return from Operation Desert Storm in June 1991. (Courtesy of the *Montgomery County Chronicle* archives.)

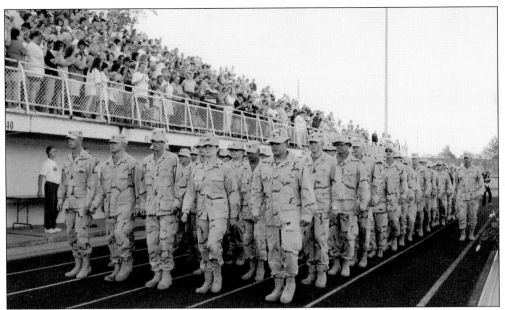

Soldiers with the US Army Reserves' 1011th Quartermaster Company march in formation at a ceremony at Shulthis Stadium following the company's return home from Iraq in the summer of 2004. (Courtesy of *Montgomery County Chronicle* archives.)

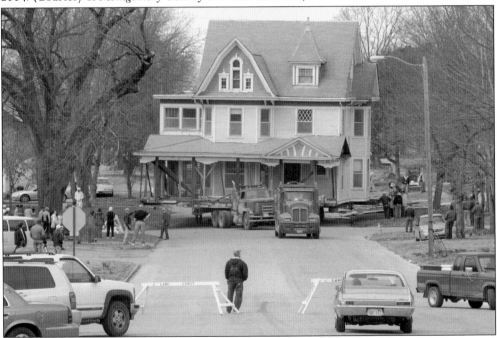

Moving the home of former Kansas governor and presidential candidate Alfred Landon from its original location, at 300 East Maple Street, in 2005 took plenty of precision and patience. The home was moved to its current location, 300 South Eighth Street, where it was revitalized and reopened as the Landon Center, a setting for community events and functions. The 1901-era Queen Anne structure served as the official home to Alfred and Theo Landon when the Landons resided in Independence from 1915 to 1937. (Courtesy of *Montgomery County Chronicle* archives.)

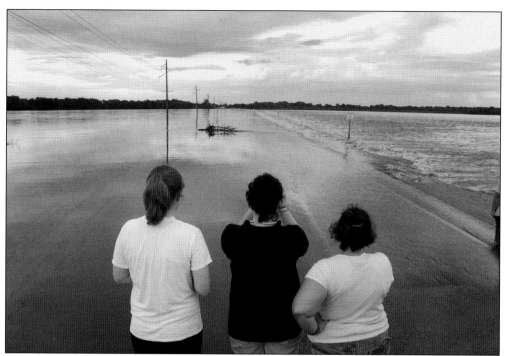

In early July 2007, the Elk and Verdigris Rivers swelled to record-setting levels. US 160, east of Independence, was closed as the river hit a record crest of 52.40 feet, almost five feet higher than the previous record set in 1943. Floodwaters also decimated several neighborhoods, especially those in the low-lying areas on Cottonwood Street, west of Park Street. (Courtesy of *Montgomery County Chronicle* archives.)

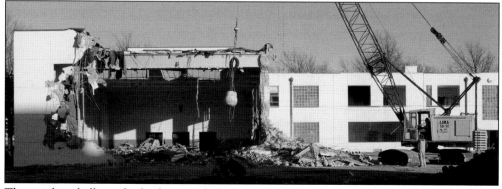

The wrecking ball was the final answer for Lincoln Elementary School in January 2011. The school, at 700 West Myrtle Street, along with its sister institution, Washington School, closed following a vote of Independence voters to erect a new school building. Jefferson Elementary School serves students from grades three to six. (Courtesy of *Montgomery County Chronicle* archives.)

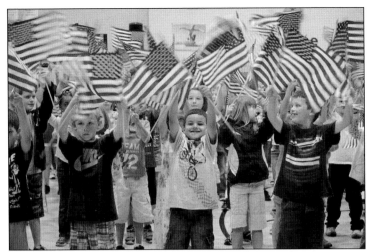

Students at Eisenhower Elementary School wave American flags during a patriotic ceremony in September 2013 as a send-off to the US Army Reserves' 1011th Quartermaster Company on its one-year tour of duty in Afghanistan.

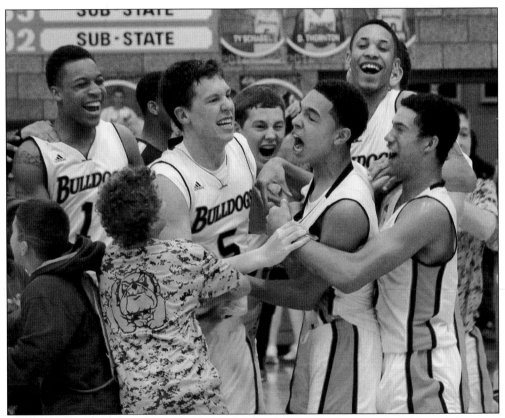

Celebration and pandemonium erupted in a January 17, 2014, boys' basketball game between Independence High School and rival Field Kindley High School of Coffeyville. Independence player Tate Turner (third from right) hit a buzzer-beating three-point field goal to lift the IHS Bulldogs to a 43-42 win over the Field Kindley Golden 'Nado. (Courtesy of *Montgomery County Chronicle* archives.)

Three

INDEPENDENCE

ARMY AIR FIELD

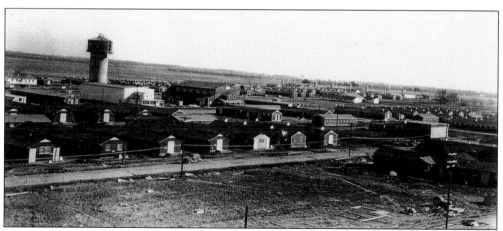

Independence Army Air Field, built in 1942, was one of 18 Kansas airfields that contributed to the nation's military effort during World War II. The huge air base was constructed in less than 18 months and served as the training ground for hundreds of future pilots. (Courtesy of Mark Metcalf collection.)

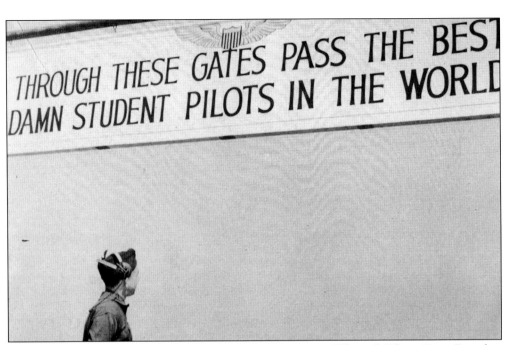

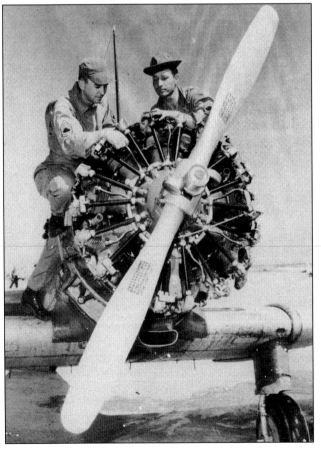

"Through These Gates Pass the Best Damn Student Pilots in the World," reads the sign to the entrance of Independence Army Air Field. Although the air base was open for only three years, hundreds of cadets gained their earliest knowledge of aviation and piloting by flying the skies above Independence. (Courtesy of Mark Metcalf collection.)

Because Independence Army Air Field was a training ground for pilots, the site was a haven for aviation mechanics, all of who became masters of the single-engine aircraft that served as the training vehicles for the student pilots. (Courtesy of Mark Metcalf collection.)

Independence Army Air Field graduated its first class of cadets in 1943, but hundreds of other cadets were involved in the mechanics and support structure of the pilot-training effort. The Independence Army Air Field yearbook of 1943 reads, "For every man in the air, there are fifteen men on the ground whose functions are to keep 'em flying. To them the expression, 'Keep 'Em Flying' is more than a patriotic catchword. Upkeep of planes and speedy handling of routine work is important." (Courtesy of Mark Metcalf collection.)

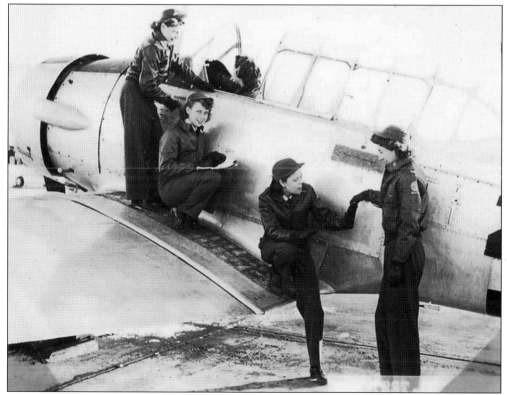

Although the official yearbook of the Independence Army Air Field mentioned on-base female personnel only as nurses, the air base did have several women in the pilot training program. The Women Airforce Service Pilots, also known as WASPs, played a key role in the preparation of America's military during World War II. (Courtesy of Mark Metcalf collection.)

To get their minds off the rigors of military training, cadets at the Independence Army Air Field enjoyed free time at dances held in the air base's consolidated mess hall. (Courtesy of Mark Metcalf collection.)

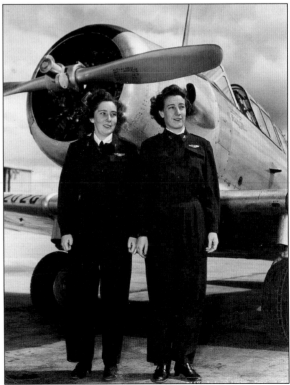

These two unidentified members of the WASP program stand in front of a single-engine airplane at the Independence Army Air Field. (Courtesy of Mark Metcalf collection.)

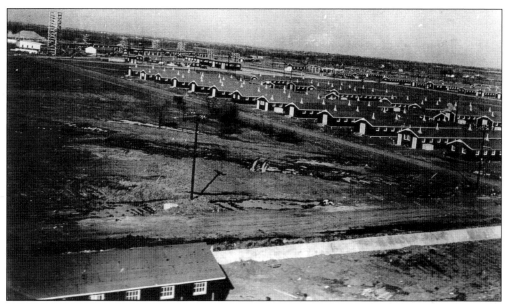

Independence Army Air Field was a community in itself, albeit one built in less than 18 months on a prairie four miles south of Independence. More than 200 structures would occupy the air base, which was one of 18 in Kansas used to train pilots. (Courtesy of Mark Metcalf collection.)

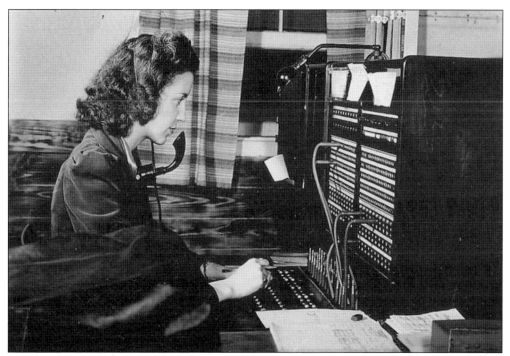

Independence Army Air Field was a working city, complete with a telephone dispatcher to transfer calls to one of dozens of buildings on the premises. (Courtesy of Mark Metcalf collection.)

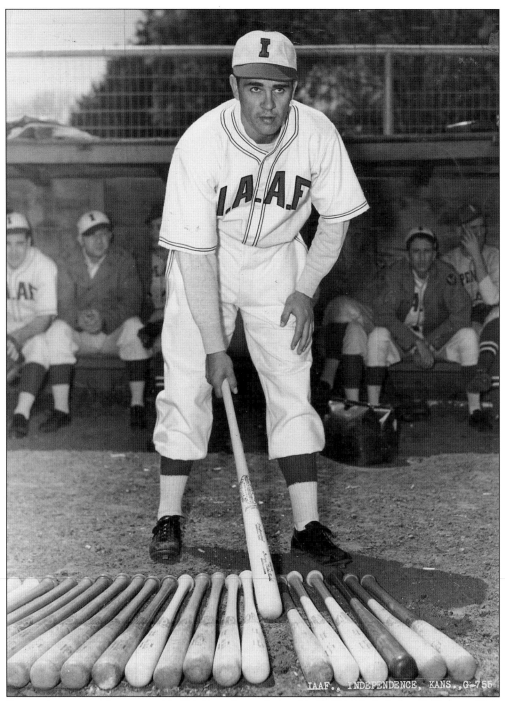

Recreation among the personnel of Independence Army Air Field included a baseball team. This unidentified batter prepares to warm up his swing prior to a game at Shulthis Stadium. (Courtesy of Mark Metcalf collection.)

Four

RIVERSIDE PARK AND ZOO

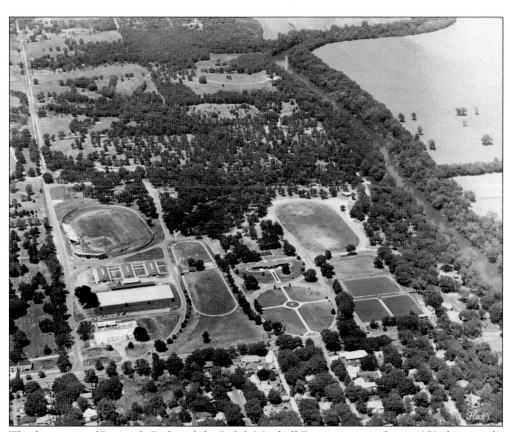

The footprints of Riverside Park and the Ralph Mitchell Zoo, as seen in this c. 1959 photograph, remained largely unchanged since the park was established in 1914. Over the decades, some of the amenities and attractions have changed. (Courtesy of Ned Stichman collection.)

The Stich Shelter House at Riverside Park has been the setting of numerous family portraits. Mrs. John Stichman (left), Annie Atkins (center), and John Stichman Sr. pose for a photograph in the 1920s. (Courtesy of Ned Stichman collection.)

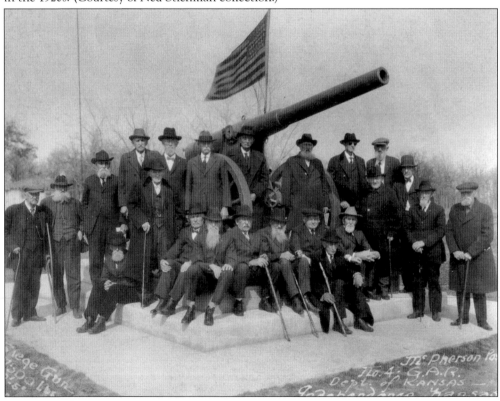

Members of the McPherson Post No. 4 of the Grand Army of the Republic pose for the camera in 1925 in front of the cannon that served as a war memorial in Riverside Park. Pictured are veterans of the Union Army during the Civil War. They include, from left to right, (seated) D.T. Whitten, Peter Schmidt, J.M. Shultz, Sam Atkinson, A.G. Bardwell, Sam Walker, Joseph Humes, and B. Merritt; (standing) Moses O'Brien, E.J. Tribble, Robert Paul, J.K. Snyder, Curtis Rork, D. Paynter, H.J. Wilkey, J.W. Foreman, M.B. Soule, R.L. Sturges, E.B. Webster, H.W. Conrad, Milton Gregory, J.C. Vance, and H.C. Jewett. (Courtesy of Independence Public Library collection.)

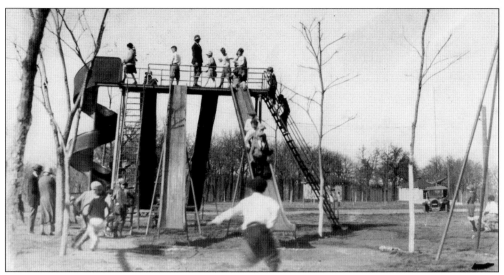

When the curlicue slide at Riverside Park was installed in 1920, it proved to be a major attraction and a big hit for park guests. Note the war memorial cannon in the background (above the car), located where the present-day carousel now stands.

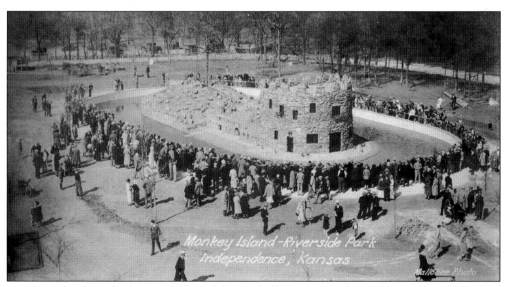

Monkey Island, at the heart of the Ralph Mitchell Zoo, opened in 1932 amid much fanfare. The facility was built through local employment efforts prior to the New Deal programs of the Franklin D. Roosevelt administration. One resident of Monkey Island, a rhesus monkey named Miss Abel, was used by NASA as a space chimp in a 1959 suborbital mission to test the effects of weightlessness and space flight on mammals. (Courtesy of Ned Stichman collection.)

This bird's-eye view of the Riverside Park Swan Pond, taken from one of the light towers at the Riverside Park stadium in the late 1930s, shows several animal pens and the tourist camp shelter house. The original park train is visible at the lower right. The location of the present-day Kiddie Land playground area is north of the parking lot. (Courtesy of Ned Stichman collection.)

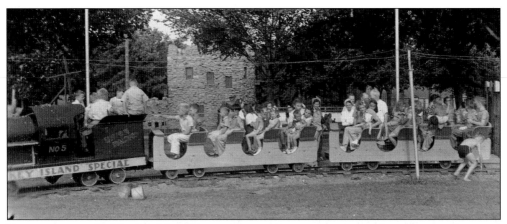

For many years, the Monkey Island Express, a two-car passenger train, chugged around an oval track west of Monkey Island and south of the Swan Pond at Riverside Park. The train was removed in the 1950s to make way for animal exhibits. A different miniature train was installed in the late 1950s in an area east of the 4-H buildings.

Seen here is the animal exhibit along the ravine at the Ralph Mitchell Zoo shortly after its original construction. (Courtesy of Ned Stichman collection.)

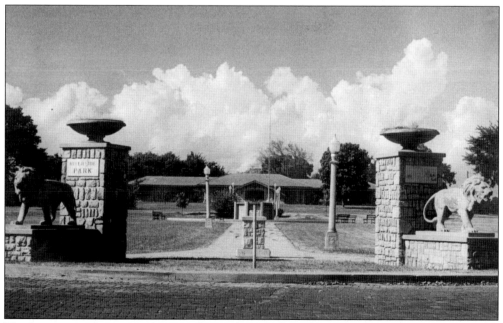

The lion statues have served as guardians of Riverside Park's Stich Shelter House entrance for years. This photograph shows the entrance at a time when Oak Street was paved with brick.

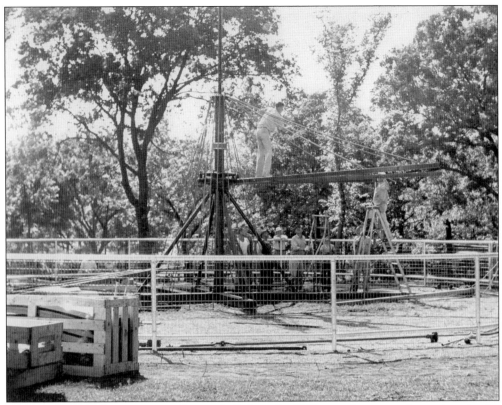

The biggest attraction to come to Riverside Park in the 1950s was the carousel, seen here in the early stages of construction in 1950. (Courtesy of Ned Stichman collection.)

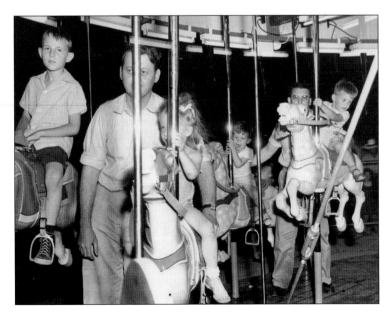

The carousel at Riverside Park proved to be a big hit when it opened in July 1950. More than 10,000 rides were given to local kids and families in the first two days of the carousel's operation. Pictured here are Donald Grabham with his children and John Stichman (right) with son Steve Stichman (far right). (Courtesy of Ned Stichman collection.)

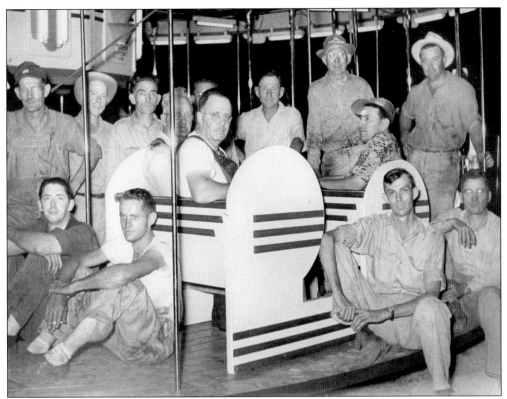

Completion of the carousel at Riverside Park in July 1950 called for a photograph of park staff and construction workers. Among the people identified are, from left to right, (seated on platform) Mel Loomer, Frank Banks, R.J. Bluejacket, and L.A. Sherwood Sr.; (in seats) ? Ramsey, Carl Casey, and Emmett Wilson; (standing) ? Lawson, ? Toomey, ? Lacy, G.H. Hackmaster, Floyd Bryant, and Louis Oliphant. (Courtesy of Ned Stichman collection.)

The 4-H buildings at Riverside Park were constructed in 1956. They have remained in use for civic functions and the annual Montgomery County 4-H Fair held each July. (Courtesy of Ned Stichman collection.)

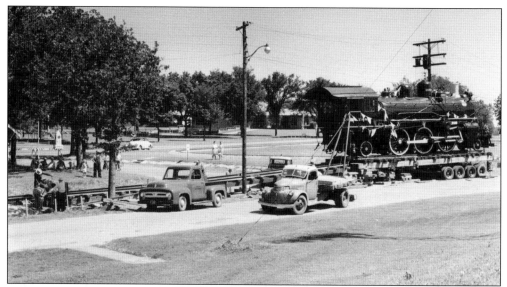

Santa Fe engine No. 1050 came to Independence in 1955 after a successful subscription effort in which residents contributed $1 each. The steam engine was fully painted at the Santa Fe shops in Topeka prior to its arrival in Independence. (Courtesy of Ned Stichman collection.)

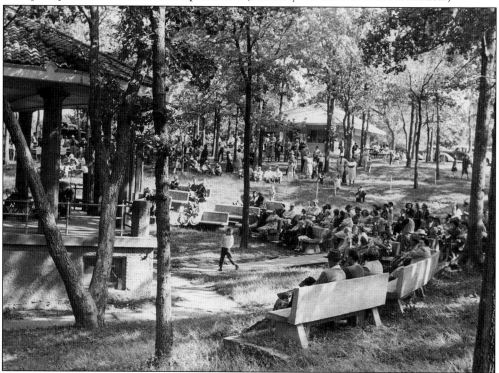

The shady grounds of Riverside Park welcome workers and their families of the Union Gas Company during a company picnic in 1951. Riverside Park, which opened in 1918, remains one of Independence's most treasured venues, complete with a band shell for weekly concerts of the Mid-Continent Band, a zoo, miniature-golf course, vast playgrounds, a carousel, and a miniature train, which is a thrill for young and old on any summer evening.

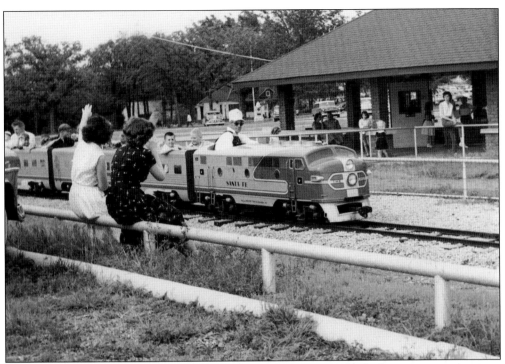

The Riverside Park train was a major attraction when it was established in its current location in 1960. Here, the train whistles past several park spectators. The train canopy had not yet been constructed when this photograph was taken. (Courtesy of Ned Stichman collection.)

Riverside Beach underwent a new look in the early 1960s. The pool replaced the 1920s-era pool that had served residents for several generations. (Courtesy of Ned Stichman collection.)

The sea lion habitat, built in the 1950s, was removed years later. It was located east of the Lions' Den concession stand. (Courtesy of Ned Stichman collection.)

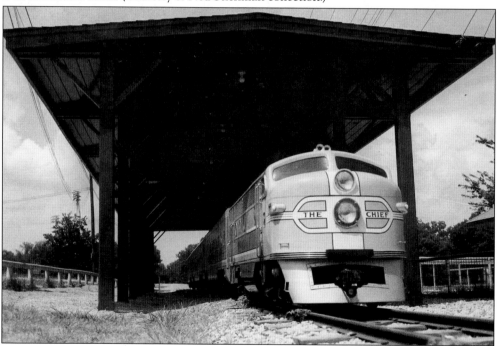

The Chief locomotive is parked under the new canopy of the Riverside Park miniature train station in this c. 1960 photograph. The locomotive was named *The Chief* in honor of the Santa Fe Railroad's celebrated Southwest Chief rail line, which connected Chicago and Los Angeles. (Courtesy of Ned Stichman collection.)

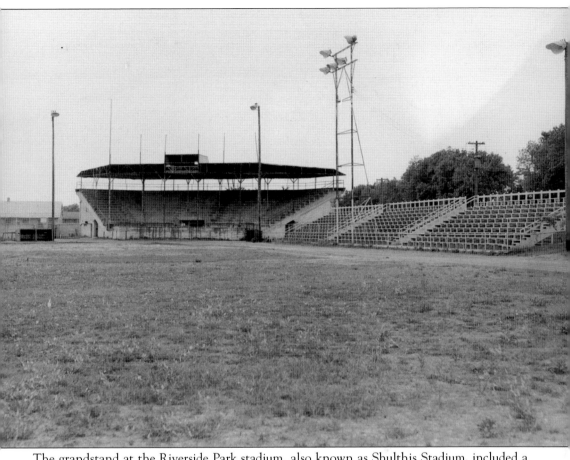

The grandstand at the Riverside Park stadium, also known as Shulthis Stadium, included a canopy and announcer's box during the years it was home to the Independence Yankees and the Independence Browns of the KOM (Kansas Oklahoma Missouri) League. The teams were organized in Class D, the smallest classification in the minor-league baseball system.

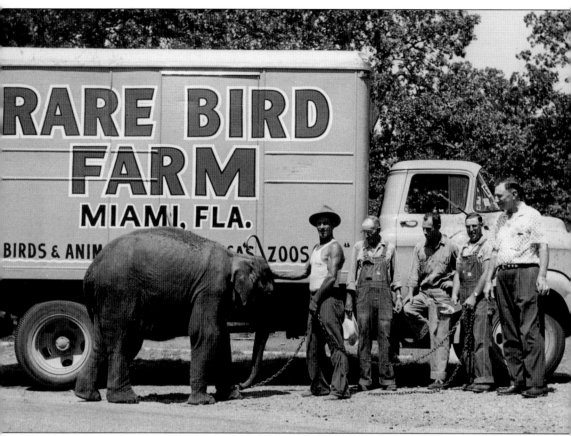

Susie the elephant was the Ralph Mitchell Zoo's newest resident in 1954. (Courtesy of Ned Stichman collection.)

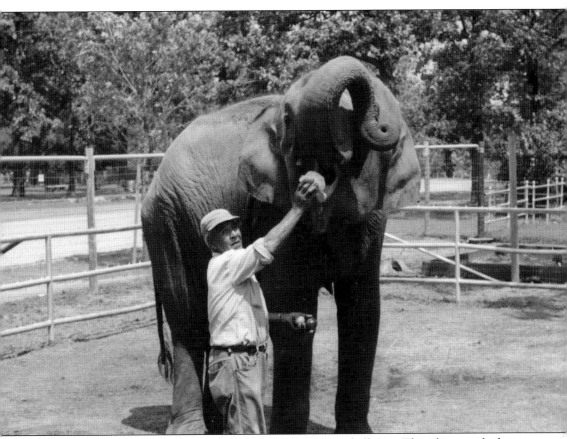

Susie the elephant was a prime attraction at the Ralph Mitchell Zoo. This photograph shows Juan Valverde, zoo curator, feeding the elephant in the animal pen. Susie was a resident of the zoo from 1959 until 1973. (Courtesy of Ned Stichman collection.)

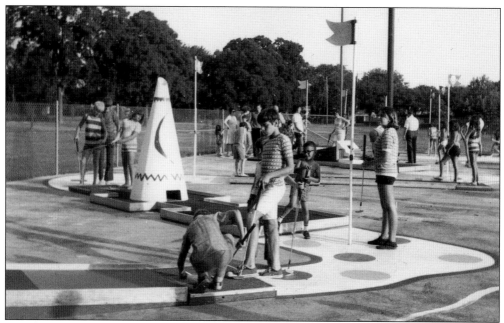

Riverside Park's first miniature-golf course was located south of the passenger train ticket booth. This photograph, taken in 1973, shows park guests enjoying the course. It was removed in the late 1970s but was replaced with an 18-hole course built north of the train ticket booth in the mid-1990s.

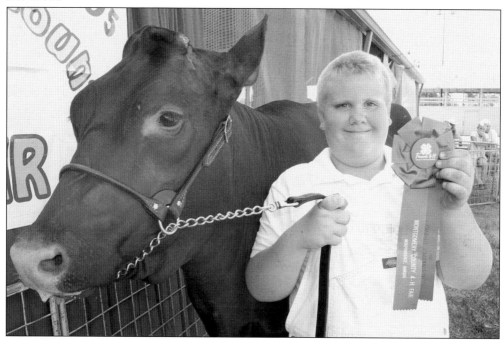

Each summer, Riverside Park becomes the central point of activity for 4-H clubs across Montgomery County. Dozens of 4-H youths have gathered at the park for one week in late July for the annual Montgomery County 4-H Fair. In 2005, 4-H youth Gabe Evans proudly displays the purple ribbon he won in the dairy cattle competition. (Courtesy of *Montgomery County Chronicle* archives.)

Five

NEEWOLLAH

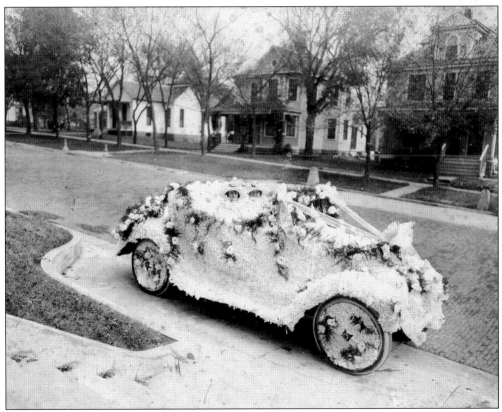

This 1924 photograph shows a Neewollah parade float sponsored by Truby Jewelers. All aspects of the vehicle, except the rubber tires, are covered in flowers. (Courtesy of John Koschin collection.)

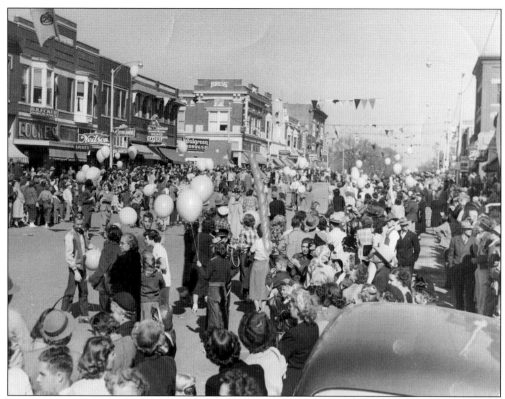

Pennsylvania Avenue is transformed into a teeming metropolis of spectators, concessions, and balloons in this 1950s photograph of the Neewollah Grand Parade. The image looks to the north. (Courtesy of Independence Public Library collection.)

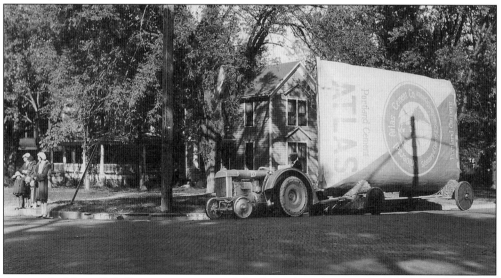

Among the Neewollah float entries in one of the festival's earlier parades was this enlarged bag of Portland cement, made possible by the Universal Atlas Cement Company of Independence. Universal Atlas often produced grandiose floats to promote its latest achievements in the cement and construction trade. (Courtesy of Mark Metcalf collection.)

The Universal Atlas Cement Company created a clever Neewollah Parade float showing a working Ferris wheel. Children were placed in each of the six seats. This photograph was taken around 1929. (Courtesy of John Koschin collection.)

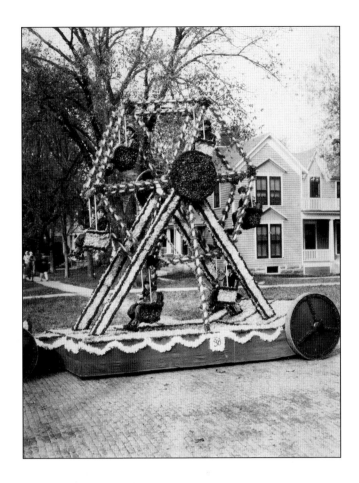

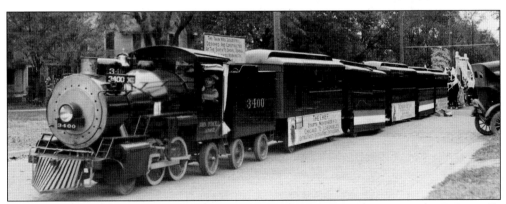

Among the highlights of the early Neewollah parades was the Atchison, Topeka & Santa Fe Railroad miniature train, which was used to advertise Santa Fe passenger train service. Train engine No. 3400 and its reduced-size passenger cars were designed and constructed at the railroad company's shops in Topeka, Kansas, and brought to Independence via railcar. (Courtesy of Josh Koschin collection.)

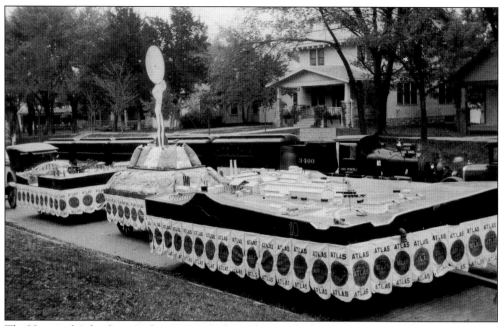

The Universal Atlas Cement Company in Independence provided this elaborate float for a Neewollah Parade. The float displays a diorama of the cement plant, located southeast of Independence.

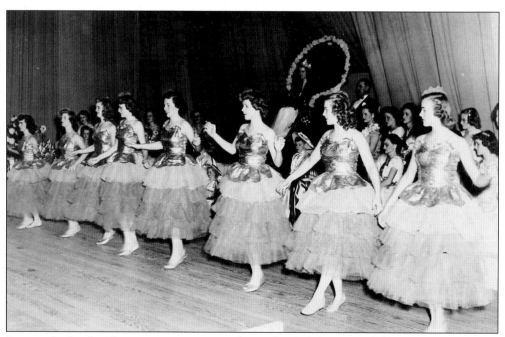

Dancers display their finest moves in a routine during the 1949 Queen Neelah coronation ceremony. (Courtesy of the Independence Public Library collection.)

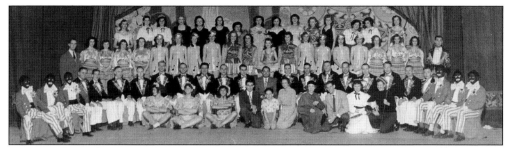

Cast members of the 1950 Neewollah play pose for a photograph on the Memorial Hall stage. Note the actors who appear in blackface, as seen at the far left and far right wings of the seated row. The use of blackface, whereby white performers would wear theatrical makeup to depict African American stereotypes, was widely accepted in that era. (Courtesy of Independence Public Library collection.)

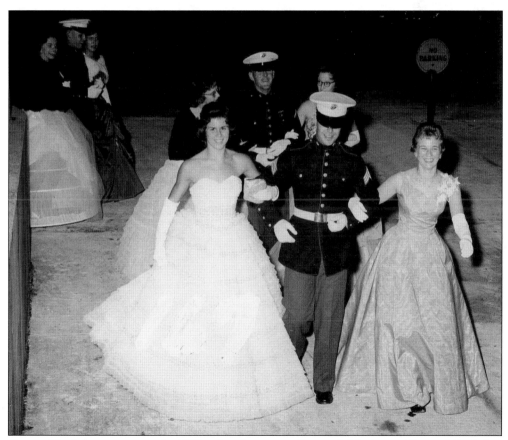

Queen Neelah contestants in 1962 take the arms of several Marine soldiers while being ushered into Memorial Hall for the coronation ceremony. (Courtesy of Independence Public Library collection.)

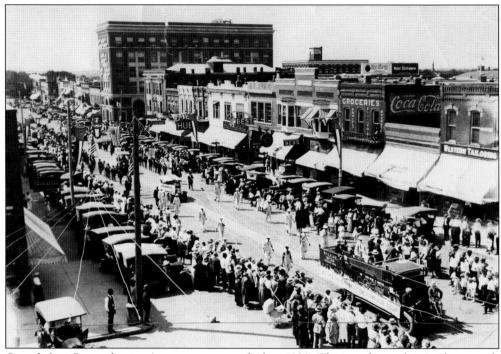

Crowds line Pennsylvania Avenue sometime before 1920. This southwest-facing photograph was taken from the second or third floor of the Independence Business College at Pennsylvania Avenue and Laurel Street. The tall structure in the background is the Citizens National Bank building. The top of the Booth Hotel is seen in the background. Note the billboards atop one of the downtown structures. The advertisements are for the Mid-west Oil & Paint Company and the Hotel Baltimore.

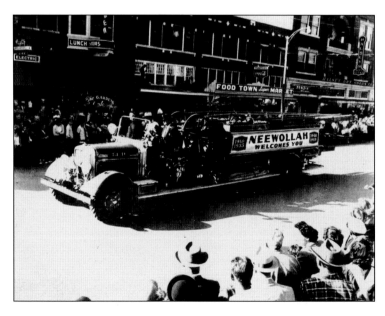

The 1949 Neewollah Parade opened with the familiar Independence Fire Department vehicle that welcomed visitors to the community. This photograph was taken at the 300 block of North Pennsylvania Avenue. (Courtesy of Josh Koschin collection.)

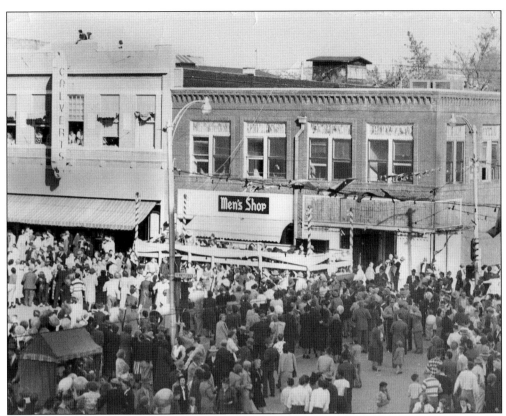

This crowd of Neewollah spectators in 1949 has gathered around the grandstand in front of Calvert's Department Store and the Men's Shop. Spectators can be seen on the Calvert's Department Store roof. (Courtesy of Independence Public Library collection.)

Queen Neelah contestants in 1960 are braving rainy conditions while waving to Neewollah Parade spectators. This was one of the few parades in Neewollah history to be delayed due to weather. (Courtesy of Independence Public Library collection.)

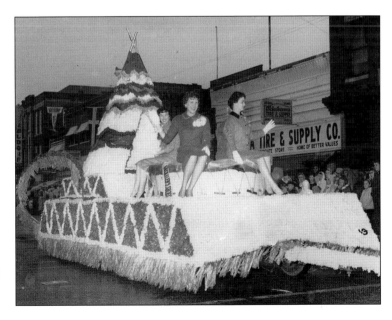

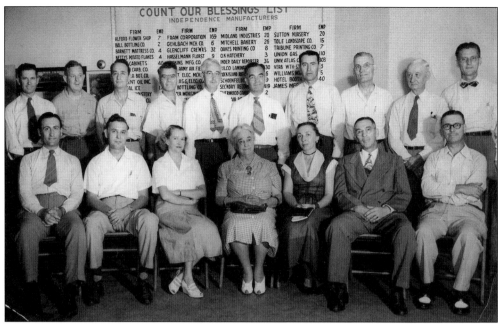

Neewollah committee members in the late 1940s included, from left to right, (seated) Frank Sinotto, Alvin Roberts, Martha Johnson, Mrs. C.E. Roth, Rachelle Wyckoff, E.R. Stevens, and W.R. Wagner; (standing) Russell Bettis, Don Wiggins, Ed Halsey, Warren Culp, Carl Guilkey, Dean Wilson, Emmett Wilson, Frank Sands, unidentified, and Harold Thompson. (Courtesy of Independence Public Library collection.)

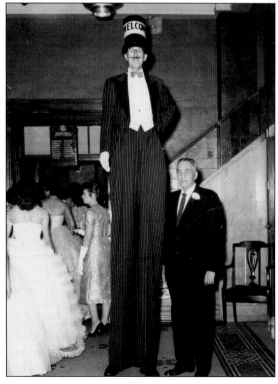

Kansas governor George Docking (right) was a regular visitor to the Neewollah celebrations during his term of office (1957–1961). Prior to viewing a Queen Neelah coronation ceremony, Docking was welcomed in a tall way by a friend of the Neewollah Festival. (Courtesy of Independence Public Library collection.)

Queen Neelah Lou McDane takes the hand of Gov. George Docking during the Neelah Ball in the Independence Civic Center in 1960. (Courtesy of Independence Public Library archives.)

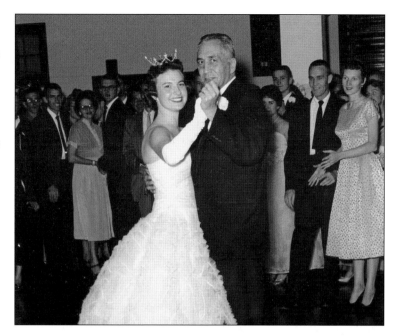

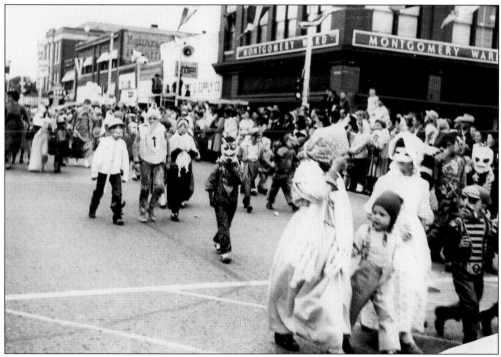

The favorite event for any child in Independence has been the Neewollah Kiddie Parade. Historically held on the Friday afternoon of the weeklong celebration in late October, the Kiddie Parade, as seen in this 1964 photograph, gives parents and friends a chance to see local kids decked out in their Halloween costumes. (Courtesy of Independence Public Library collection.)

Kansas governor Frank Carlson was a guest of honor for the Neewollah celebration during his term of office (1947–1950). Here, Carlson (left) greets constituents outside the Booth Hotel. (Courtesy of Independence Public Library collection.)

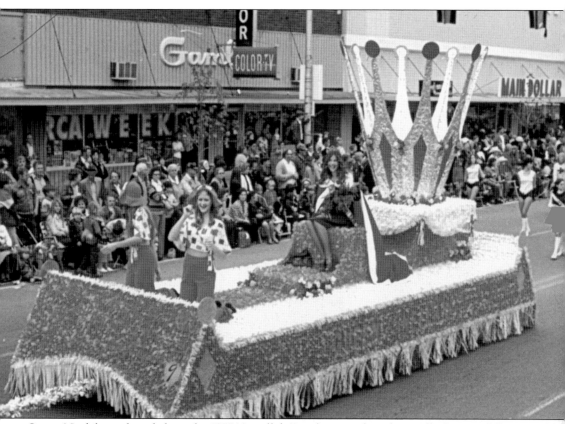

Queen Neelah is ushered along the 1977 Newollah Parade route aboard a regally decorated float. This photograph, taken by Emmett Wilson, faces northwest from the east side of the 300 block of North Pennsylvania Avenue.

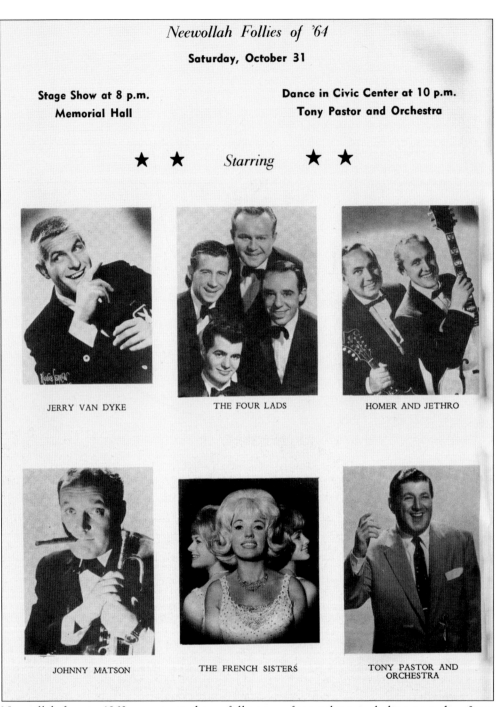

Neewollah Follies of '64

Saturday, October 31

Stage Show at 8 p.m.
Memorial Hall

Dance in Civic Center at 10 p.m.
Tony Pastor and Orchestra

★ ★ *Starring* ★ ★

JERRY VAN DYKE

THE FOUR LADS

HOMER AND JETHRO

JOHNNY MATSON

THE FRENCH SISTERS

TONY PASTOR AND
ORCHESTRA

Neewollah fans in 1963 were greeted to a full roster of top talent, including comedian Jerry VanDyke; the Canadian crooning quartet The Four Lads, best known for their hits "Istanbul (Not Constantinople)" and "Moments to Remember"; trumpeter Johnny Matson; and the country duo Homer and Jethro, known for their rendition of *The Beverly Hillbillies* theme song.

Six

PEOPLE AND PLACES

Laborers pose outside this elevator and mill sometime before 1910. This photograph was lifted from a glass negative.

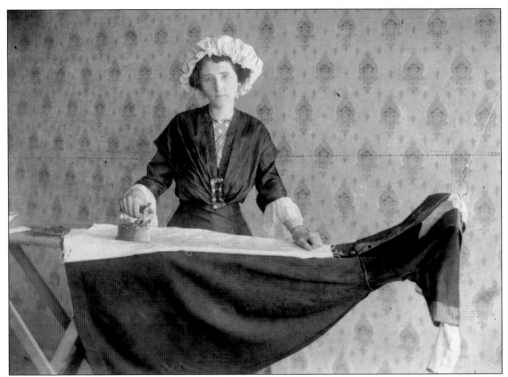

The identity of this woman is unknown, but what is known are the domestic conditions for Independence women when the 19th century transitioned to the 20th century. Note that the iron is operated without electrical power. This photograph was taken from a glass negative.

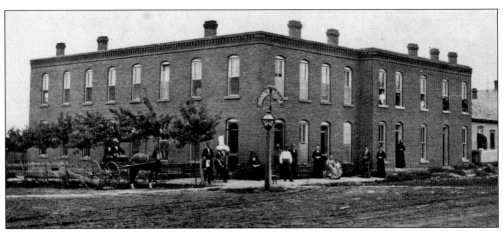

The Hoober House was one of Independence's first brick hotels. It was located at Main and Eighth Streets, the site of the present-day Booth Hotel and Apartments. This photograph was taken in the late 1870s. (Courtesy of John Koschin collection.)

The silhouette of Miss Justice is evident on the Montgomery County Courthouse, built in 1888. This northwest-facing photograph was likely taken from the intersection of Main and Sixth Streets. The statue of Miss Justice faces south toward Main Street. The angle of this image reveals the rich architectural detail of the early courthouse.

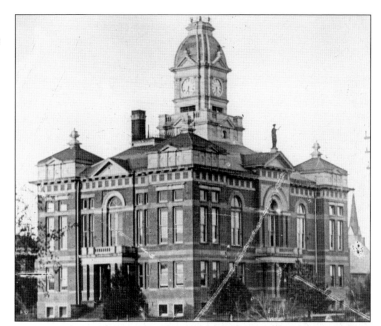

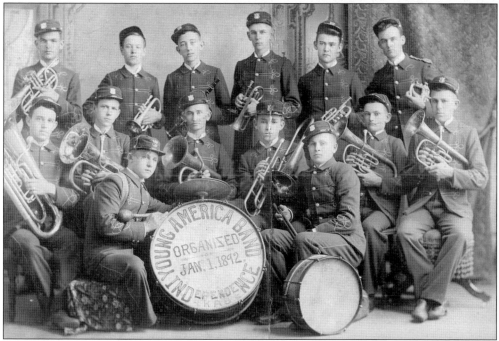

With uniform buttons firmly snapped and hats squarely affixed on heads, the members of Independence's Young America Band pose for a portrait. The band was a staple of musical entertainment in the community following its organization in 1892. The Young America Band was the precursor to the Mid-Continent Band, which has performed summer concerts at Riverside Park each week for decades. Shown here are, from left to right, (first row) Carl Roediger and Sam Bosier; (second row) Charles Hebrank, Frank DeVore, Frank Good, Bert Wilson, Harry Truman, and Dale Hebrank; (third row) Pete Johnson, Harry F. Sinclair, George Remington, Albert Anderson, Ade Frank, and Walter Sickels.

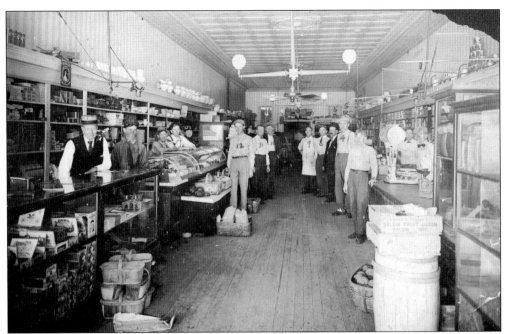

Baden Dry Goods was a staple of early-day commerce in downtown Independence. Founded by Henry Baden, the store offered everything from baking flour to hand-rolled cigars. The Baden name could be found on multiple buildings in the downtown Independence business district, as multiple generations of family members would involve themselves in the retail and wholesale goods trades. (Courtesy of Harold Baden collection.)

At one time, farmers who were unable to pay their bills or subsist on their own would find solace on a "poor farm." The farm included several massive barns, an orchard, and farmhouses for the indigent farmers and their families. A cemetery was located on the farm property for the burial of poor farm residents. The Montgomery County Poor Farm was located southeast of Independence. (Courtesy of Rick Knapp collection.)

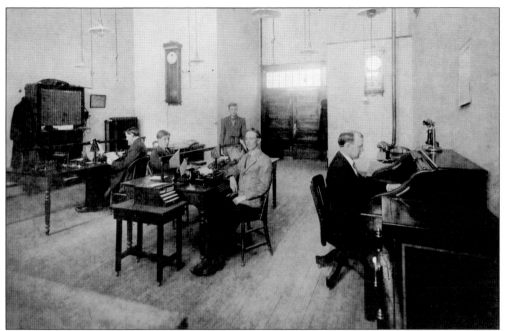

Clerks in a clutter-free Independence business pose for a photograph about 1910. Note the outlets that hang from the ceiling, indicating the first-generation sources of electric power in Independence.

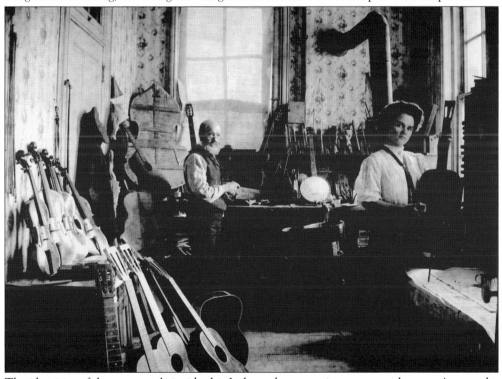

The identities of the two people inside this Independence music store are unknown. Among the instruments pictured are guitars, violins, banjos, and cellos. Also visible is the pattern for a string bass. This image was lifted from a glass negative.

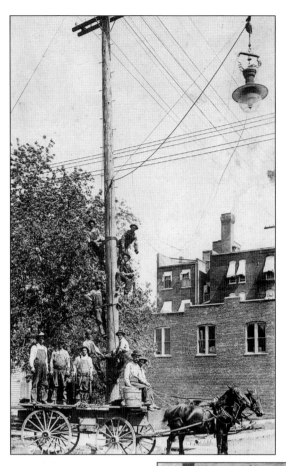

One of the first crews of electrical linemen from the Kansas Gas and Electric Company poses for this photograph behind a downtown Independence commercial property. Note the large lightbulb hanging from the fixture in the middle of the street. (Courtesy of Westar Energy collection.)

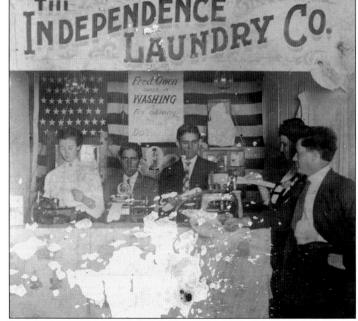

The Independence Laundry Company flew the red, white, and blue in its office in downtown Independence. The 45-star flag indicates that this photograph was taken between 1896 and 1908. It was lifted from a glass negative.

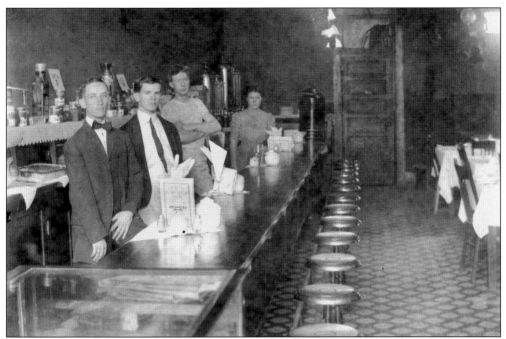

The staff of a downtown Independence eatery awaits a noon lunch crowd. Soup was served for 5¢, and a slice of cherry pie cost 10¢. This photograph was lifted from a glass negative.

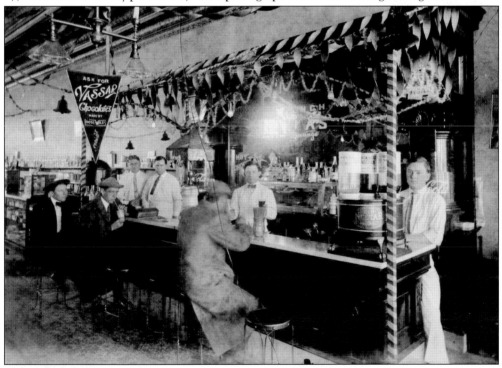

Vassar Chocolates and Coca-Cola, along with apple cider and blackberry nectar, were served in abundance at this soda fountain. The exact location of this downtown Independence establishment, seen here around 1900, is unknown.

The coffee was always warm around the *U*-shaped serving table at the Interurban Diner in downtown Independence. This photograph was taken from a glass negative.

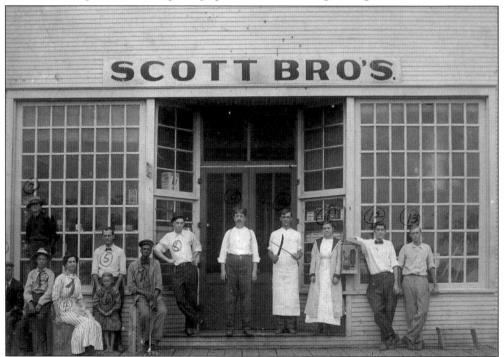

Scott Brothers Grocery served the employees and families of the United Kansas Portland Cement Company in LeHunt, located about four miles northwest of Independence.

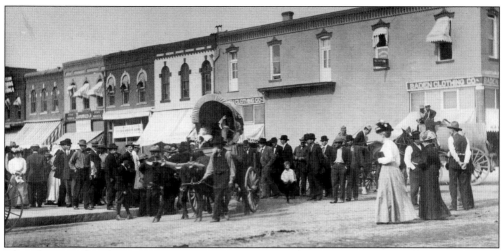

This photograph, taken in 1908 at the corner of Pennsylvania Avenue and Main Street, shows a gentleman from Fredonia guiding an ox-driven wagon. The image was snapped by Frank Foster. The exact reason for the occasion is unknown. Among the businesses seen here are the Baden Clothing Company, Potter's Variety Store, and Bowman's Fine Shoes.

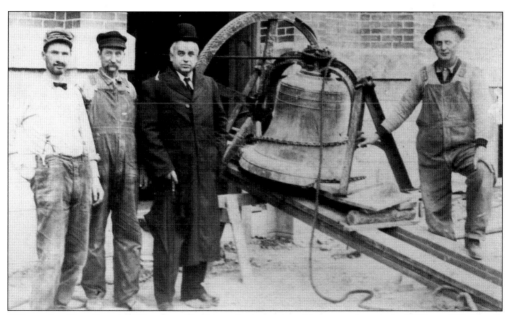

When the First Baptist Church of Independence erected its new church in 1912, at 220 South Pennsylvania Avenue, church members and contractors gathered for the placement of the bell, which had hung from the original church, built in 1870. Pictured here are, from left to right, an unidentified laborer, contractor John Franklin Keller, the Reverend W.E. Gwatkin, and an unidentified laborer.

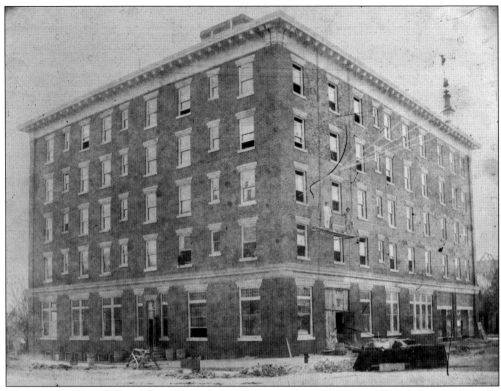

The imposing Booth Hotel, located on the southwest corner of Main and Eighth Streets, brought elegance to lodgers and visitors after the hotel's construction in January 1912. The interior included hand-laid ceramic tile floors, intricately carved plaster cornices, crystal chandeliers, and brass and solid-oak embellishments. The Booth Hotel was one of the first hotels in the Midwest to include a revolving door at its main entrance. This photograph was lifted from a glass negative.

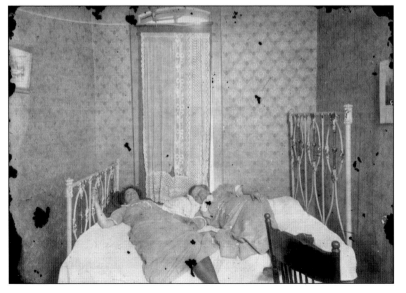

It must have been a wearying day at the turn of the century for these two women to crash on a bed. Their identities and location are unknown. The photograph was lifted from a glass negative.

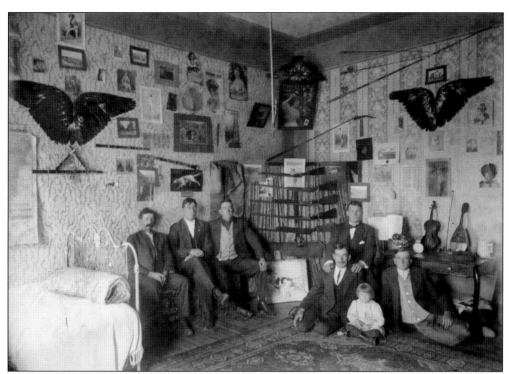

Apartment life for young bachelors in Independence in this c. 1910 photograph included a menagerie of sporting goods (guns and fishing gear hang on the walls) and musical instruments (clarinets, violin, and mandolin), plus several photographs and drawings of scantily clad women. These latter items were strategically placed on the wall for the tallest (and possibly oldest) sets of eyes in the room. This image was lifted from a glass negative.

Did a shave and a haircut cost "six bits" in Independence's early years? This photograph of a downtown Independence barbershop shows a full house. Note the customer tilted in the chair to receive a shave. A barber holds the shaving mug in his hands, and the cabinet (far left) is filled with shaving mugs. This image was lifted from a glass negative.

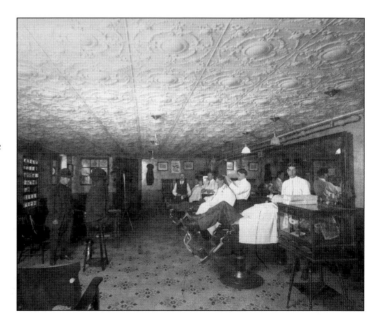

Members of McCray's Concert Band, led by Walter McCray, stand in formation in this 1909 postcard. The band is shown south of the Carnegie library on Fifth Street. The top of the Montgomery County Courthouse is visible in the background. (Courtesy of Rick Knapp collection.)

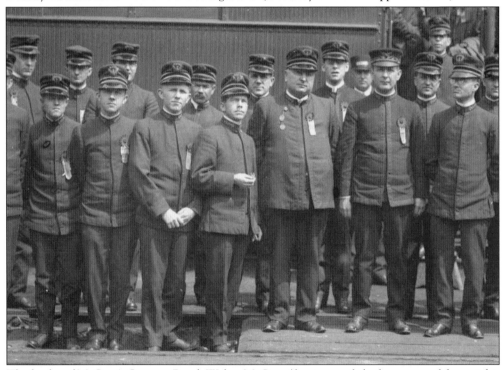

The leader of McCray's Concert Band, Walter McCray (front row of platform, second from right, hands visible at sides), had musicians from the Independence community join him as part of a delegation of southeast Kansas officials aboard a booster train that traveled to New York and other northeastern cities in 1914. (Courtesy of the Pittsburg State University collections, Axe Library special collections.)

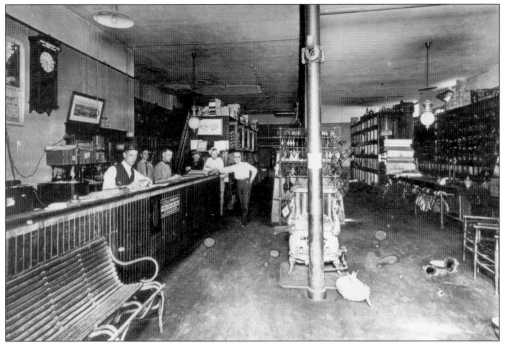

This photograph of the National Supply Company, at 112 West Myrtle Street, was taken in July 1919, as indicated by the calendar on the wall. The man on the far left is Frank Poland. To the right of Poland is Elon Robley. Note the spittoons located on the floor.

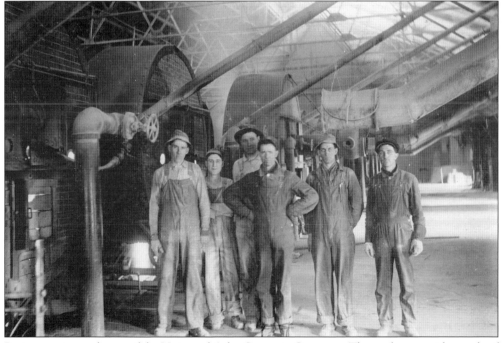

Posing are six employees of the Universal Atlas Concrete Company. The workers provide a scale of the size and enormity of the machinery and buildings of their employment. Note the large skylights that provided illumination inside the building. This photograph was taken around 1916.

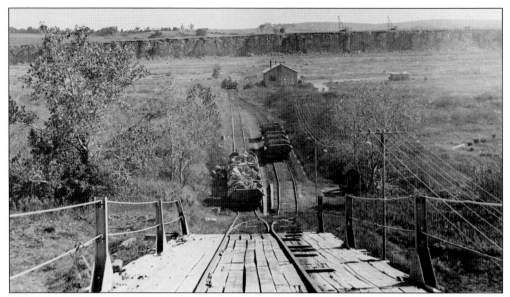

This 1943 photograph shows the limestone quarry at the Universal Atlas Cement Company. The loading and hauling of limestone was modernized in 1955, when a large crusher device was moved to the quarry floor. Rock was then hauled to the crusher in 20-ton dump trucks instead of by railcar.

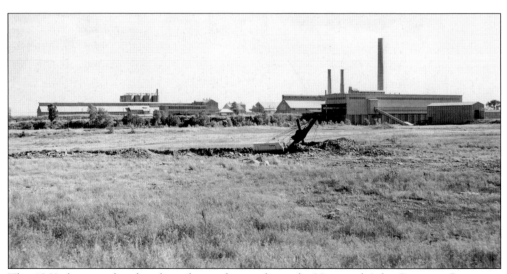

This 1960 photograph, taken from the southwest, shows the Universal Atlas Concrete Company. A shale shovel in the foreground is removing limestone from the ground to be used in the production of concrete.

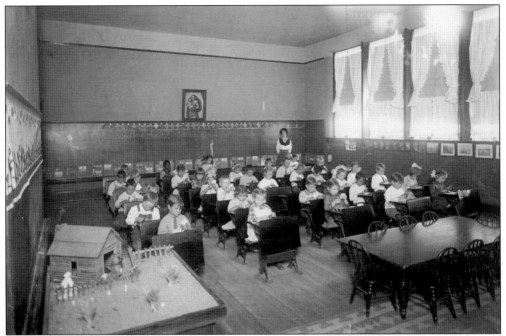

Students at Longfellow School in Independence are pictured on Halloween Day in 1914. There are 34 students in this one classroom. Note the log cabin diorama at the lower left. This photograph was lifted from a glass negative.

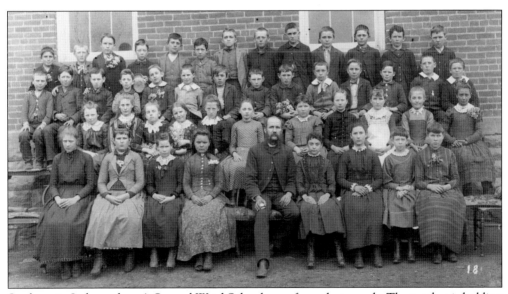

Students in Independence's Second Ward School pose for a photograph. The teacher is holding the desk bell. Many of the students are clutching flowers, while other students have adorned their lapels with flowers. This image was lifted from a glass negative.

Students of the German Lutheran School, located on the grounds of the present-day Zion Lutheran School, wear their best clothing. Even so, some children pose in bare feet in this pre-1910 photograph lifted from a glass negative.

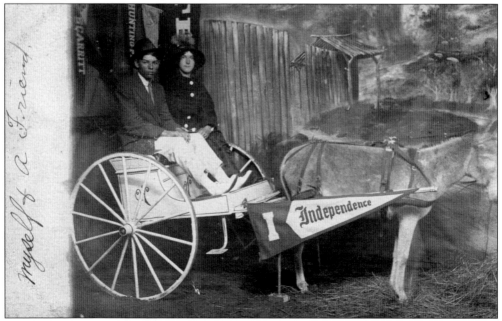

Very little is known about these unidentified Independence fans, known only as "Myself and a Friend." (Courtesy of Rick Knapp collection.)

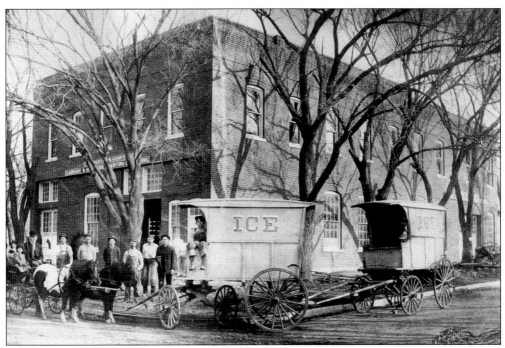

Ice-delivery wagons are shown sometime before 1910 at Eighth and Myrtle Streets. The blacksmith shop is located within the two-story building. Note the advertisement for horseshoes on one of the primary entrances to the building. This image was lifted from a glass negative.

The window in front of the Kress Store at Pennsylvania Avenue and Laurel Street is decorated in embroidered fabrics. Postcards lining the window are for sale for 1¢ each. This image, taken sometime before 1910, was lifted from a glass negative.

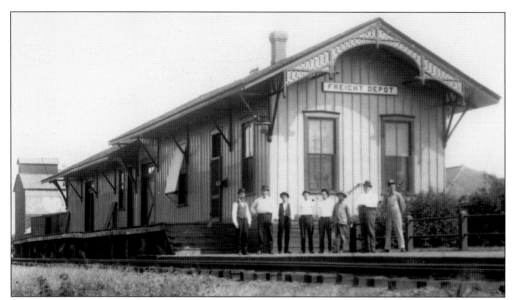

At one time, all consumer items had to enter Independence through the local freight depots. This photograph of the Missouri Pacific freight depot shows the architectural embellishments and the large platform on which boxes and crates were unloaded almost on an hourly basis. The freight depot was north of the passenger depot, located north of the present-day Main Street overpass.

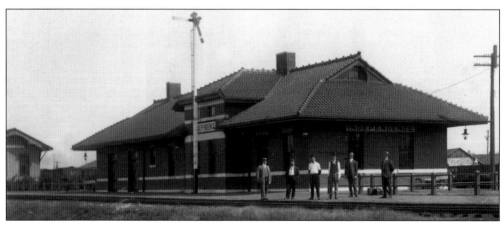

With its red-tiled roof, the Missouri Pacific passenger depot greeted passengers on a daily basis after its construction in 1905. The depot was located on the main line that ran north to south, north of the present-day Main Street overpass.

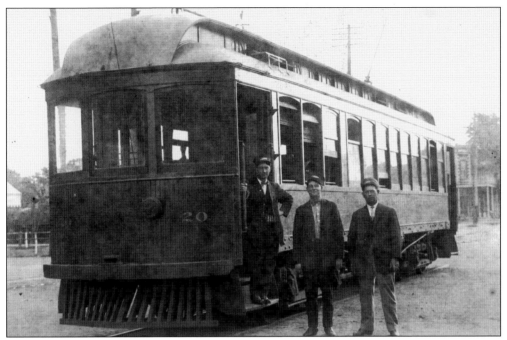

Shown here is one of the first crews aboard the Union Electric trolley car as it rolled into Independence. Note the coin device on the hip of the motorman standing on the platform. This photograph was lifted from a glass negative.

Staff members of the United Kansas Portland Cement Company pose on the porch of the company offices in LeHunt. Located on the east base of Table Mound, the LeHunt plant expanded to include a small community, which included a grocery store, school, and housing for several hundred residents.

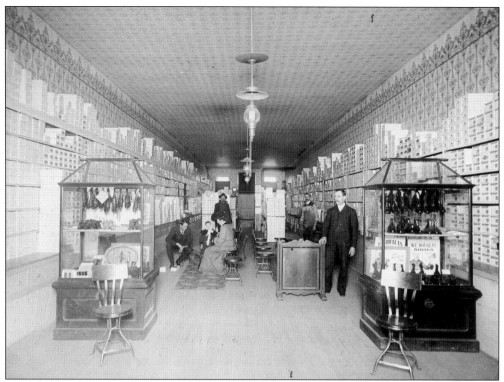

Geckler Shoe Store in downtown Independence is neat and tidy in this pre-1910 photograph lifted from a glass negative. Shoes are displayed in the two glass cases. The small number of shoes on display indicates the lack of diversity of shoe styles of the era.

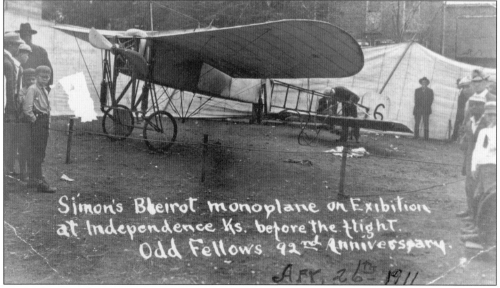

Simon's Bleirot monoplane on Exibition at Independence Ks. before the flight. Odd Fellows 92nd Anniverspary. AFR. 26th 1911

In April 1911, Independence residents have gathered around the *Bleriot XI*, an aircraft used by early aviator Louis Bleriot to make the first flight across the English Channel in 1909. This exhibit was one of the events held during the 92nd anniversary of the International Order of Odd Fellows. This image was lifted from a glass negative.

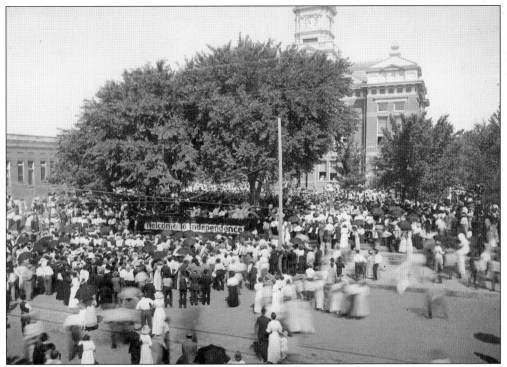

In 1910, Pres. William Howard Taft visited Independence, where he made an address from the steps of the Montgomery County Courthouse. Taft is visible immediately to the right of the utility pole in the center of the photograph. Prior to speaking in Independence, Taft gave a speech in downtown Coffeyville. (Courtesy of the Independence Public Library collection.)

More than 1,400 paying customers of the Airdome Theatre pack the bleachers and seats on May 22, 1913, for a show. (Courtesy of Josh Koschin collection.)

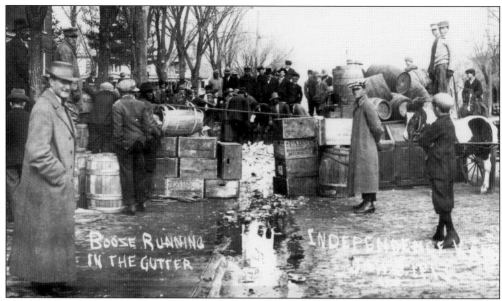

The prohibition years in Kansas and Montgomery County prompted law enforcement to raid businesses and residences that were suspected of making homemade brew or selling the illegally obtained spirits. Such was the case in January of 1913, when law enforcement, in a visible display, shattered thousands of liquor bottles and broke beer kegs in front of the Montgomery County Courthouse. (Courtesy of Rick Knapp collection.)

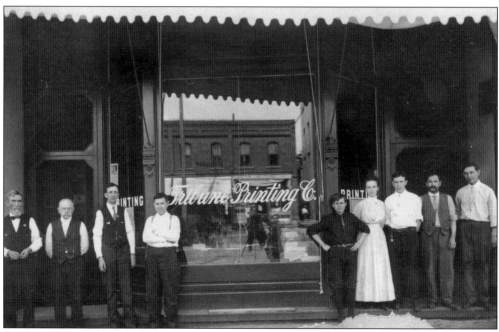

Staff members of the Tribune Printing Company on South Pennsylvania Avenue pose outside the business sometime before 1910. The photographer and his box camera on a tripod are reflected in the front window. This image was lifted from a glass negative.

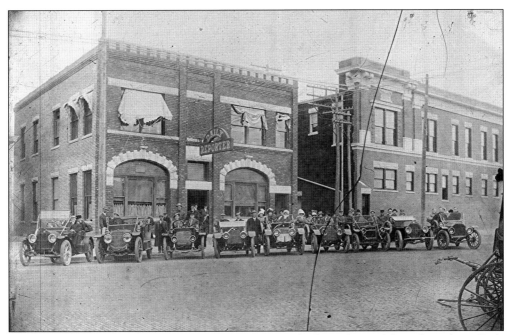

Some of Independence's early speedsters line up their vehicles in front of the *Independence Daily Reporter* offices at 112 West Laurel Street. This photograph was taken from a glass negative; note the large crack running from top to bottom. (Courtesy of John Koschin collection.)

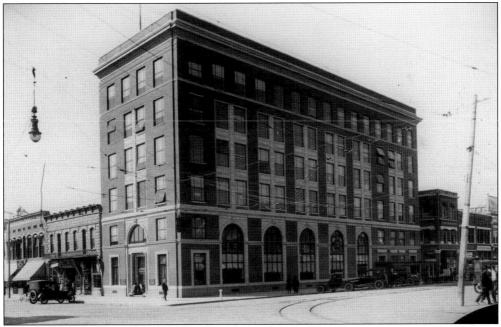

The six-story Citizens National Bank building at Myrtle Street and Pennsylvania Avenue dominated the Independence skyline when it opened in 1917. "Beautiful and harmonious in outline and coloring, substantial and solid and safe in construction, convenient and commodious in arrangement and detail, and elegant in its interior finish, it stands as a splendid ornament to the city," wrote the *Independence Reporter* on September 13, 1917.

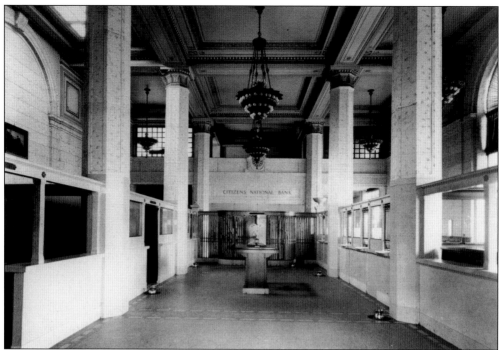

The interior of the Citizens National Bank building, constructed in 1917, was one of the more impressive for its size in the midwestern United States. The interior was illuminated with eight bronze fixtures carrying almost 400 frosted lamps. Tavernelle marble floors and travertine walls guided bank customers to the polished metal that safeguarded the bank's vault.

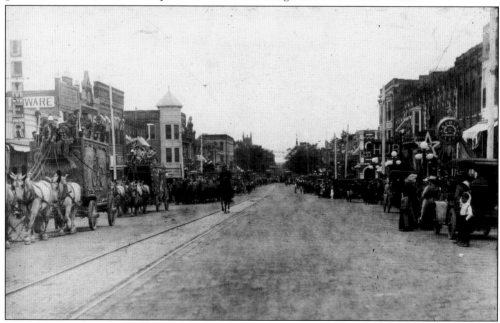

The arrival of a circus called for a parade in downtown Independence, as seen in this c. 1910 photograph lifted from a glass negative. This view looks south on Pennsylvania Avenue from the intersection of Laurel Street. Note that the third parade entry is pulled by a cluster of camels.

In the days before libraries had access to multiple book resources and interlibrary systems, book-hungry residents of Independence would be treated to a traveling bookmobile, shown here making a stop in front of the Independence Public Library in 1920. (Courtesy of the Independence Public Library collection.)

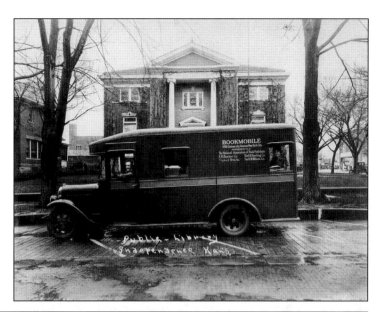

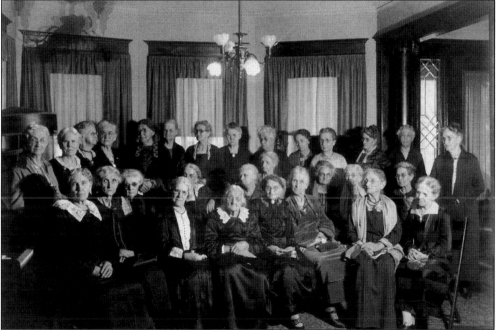

A group of pioneer women in Montgomery County is seen in the home of Ivy Darrah on January 29, 1926. A caption on the back of the photograph indicates these women were guests of the Argonia Society. Pictured are, from left to right, (first row, seated) Mrs. A.C. Whitman, Mrs. Daniel Ringle, Mrs. G.W. Waggoner, Mrs. E.M. Wark, Mrs. B.F. DeVore, and Mrs. L.W. Humphrey; (second row, seated) Mrs. W.D. Felts, Mrs. R.H. DeMott, Mrs. C.C. Kincaid, Mrs. J.H. Pugh, Mrs. Elvira Stoops, Mrs. Sarah Bloxom, Mrs. Mary Huddleson, Mrs. Mary Goodell, and Mrs. Jennie O'Brien; (back row, standing) Mrs. Thomas Yoe, Mrs. Clara Whitman, Mrs. G.W. Finley, Mrs. B.F. Masterman, Mrs. Moses O'Brien, Mrs. S.J. Shearer, Mrs. E. Utterback, Mrs. William Inge, Mrs. J.E. Thibus, Mrs. John Howe, Mrs. D.C. Krone, Mrs. Amanda VanSant, Mrs. I. Wycoff, and Mrs. E.P. Allen. (Courtesy of Independence Public Library collection.)

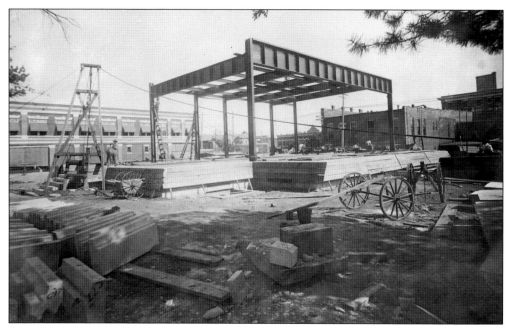

The steel frame of the Independence Post Office at Eighth and Myrtle Streets takes shape around 1918. The photograph is looking southeast toward Main Street. The Booth Hotel is visible at the far right.

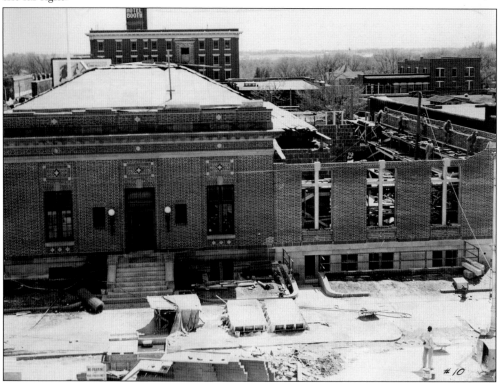

An addition to the Independence Post Office, at Eighth and Myrtle Streets, expanded the size and scope of the local postal facility. The Booth Hotel is visible in the background.

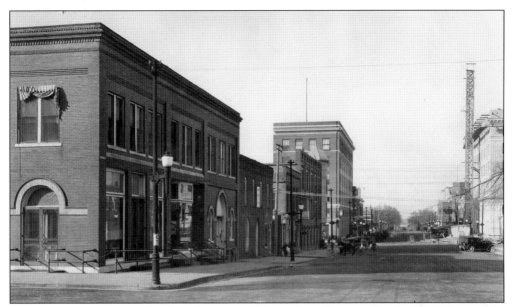

This west-facing photograph of the downtown Independence business district in 1920 was taken from the intersection of Sixth and Myrtle Streets. The large building with the arch-shaped windows and doors would be demolished in a 1989 natural-gas explosion. The Professional Building, located at the far right, is shown under construction.

Employees and officers of the Baden Wholesale Grocery business pose for the camera sometime in the 1930s. They are, from left to right, Frank Cain, an unidentified bus driver, Fred Baden, Barney McCraken, Slick Lessman, an unidentified man, Frank Michener, Claude Hagedorn, John Fienen Sr., J.W. Fiz, John Greenlee, August Baden, and Henry Baden Jr. This photograph was taken at the 100 block of East Myrtle Street. (Courtesy of Harold Baden collection.)

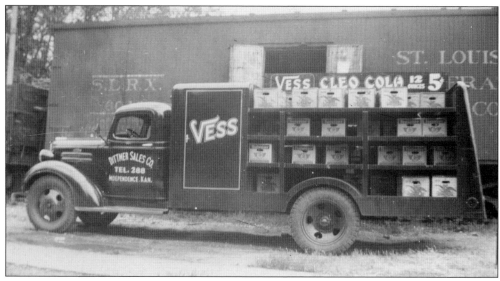

Dittmer Sales Company, located on the 200 block of West Main Street for many years, was a distributor for soda and beer. This photograph of a Dittmer truck shows Budweiser boxes ready to be distributed. Vessa Cleo Cola was sold for 5¢ in 12-ounce bottles.

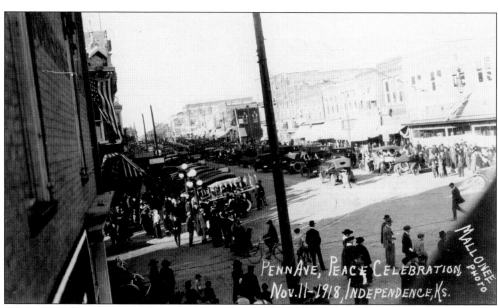

When news of the signing of the armistice ending World War I reached Independence on November 11, 1918, the town erupted in a joyous celebration. This photograph looks north on Pennsylvania Avenue from south of Main Street. (Courtesy of Rick Knapp collection.)

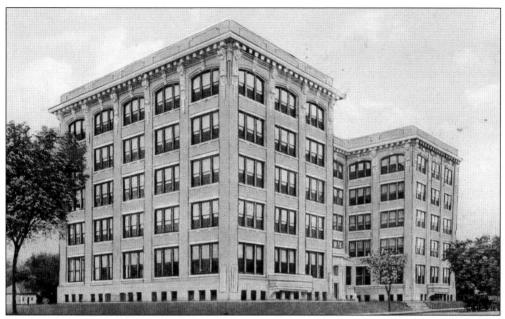

The headquarters of the Prairie Oil and Gas Company, located at Tenth and Myrtle Streets, dominated the Independence skyline after its construction in 1916. An addition to the structure was built in 1928. (Courtesy of Ken Brown collection.)

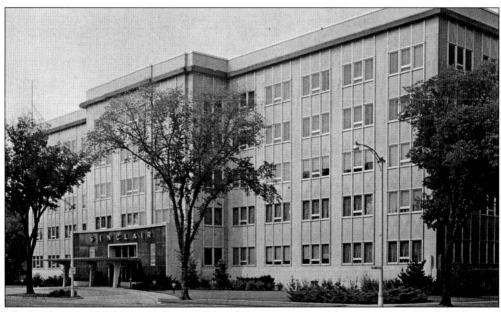

The headquarters of the former Prairie Oil and Gas Company underwent a major face-lift following the company's acquisition by Sinclair Oil Company. Founded by former Independence pharmacist Harry F. Sinclair, the Sinclair Oil Company would be embedded in the history of Independence for years until its eventual purchase by the Atlantic Richfield Company (ARCO). Note the Sinclair name above the front entrance. (Courtesy of Westar Energy collection.)

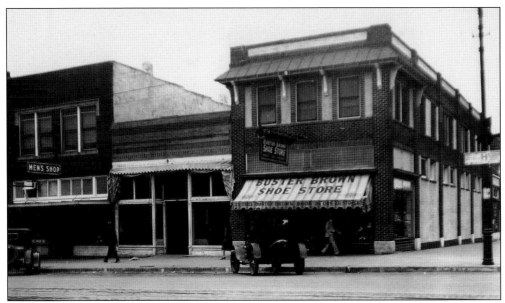

The Buster Brown Shoe Store, at the southwest corner of Pennsylvania Avenue and Laurel Street, included a fabric awning that cooled customers and pedestrians from the summer sun. The highway sign on the utility pole reads, "Northwestern Highway," an indication of the naming of the highway system prior to the numerical identification system. The sign directed southbound motorists to Mound Valley, Oswego, and Columbus and northbound motorists to Neodesha, Topeka, and Wichita. (Courtesy of Independence Public Library collection.)

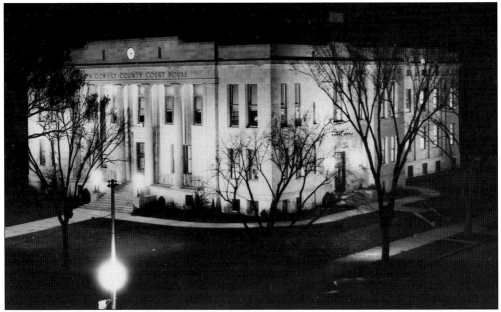

The Montgomery County Courthouse underwent a massive renovation in the early 1930s. The courthouse structure was stripped of its Victorian architectural elements and was encased with concrete and stone. The courthouse was also extended to the north (the newer wing is visible to the right of the tree on the right). The renovated courthouse also had an illuminated clock, much like its predecessor, above the front entrance. (Courtesy of Westar Energy collection.)

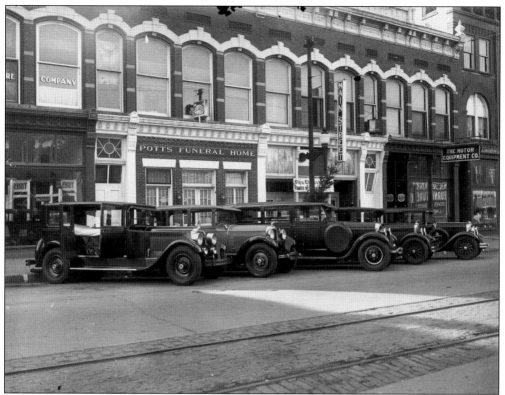

Hearses belonging to Potts Funeral Home line the street in front of the establishment, located on the south side of the 100 block of West Main Street. (Courtesy of John Koschin collection.)

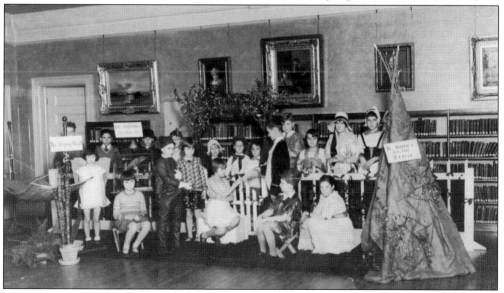

Schoolchildren gather at the Independence Public Library for a skit about Dr. Doolittle. Signs used in the skit read as follows: "Dr. Doolittle's Strictly Private Office," "No Sleeping Aloud," and "No Admittance . . . This Mans You!" This skit is believed to have been performed in the 1930s or 1940s. (Courtesy of Independence Public Library collection.)

Appliances of the 1920s included Hoover vacuums (as displayed above the office entrance), oscillating desk fans, lightbulbs, and electric irons. This photograph is believed to have been taken in downtown Independence about 1927. (Courtesy of Westar Energy collection.)

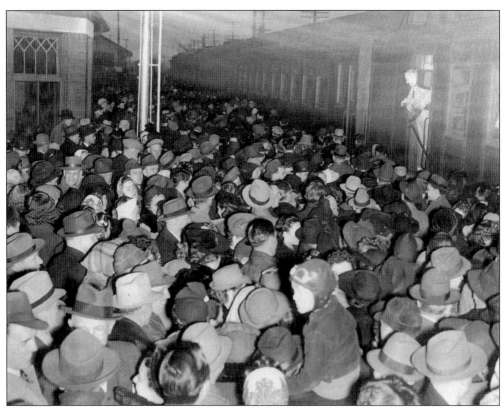

Alf Landon, the longtime Independence resident who was elected Kansas governor in 1932 and again in 1934, was the Republican nominee for president in 1936. Landon traveled to Independence to cast his vote in the presidential election. He departed his hometown amid fanfare, with adoring citizens standing on the Santa Fe depot platform.

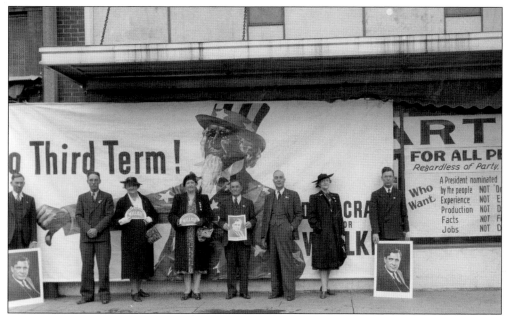

Just four years after Independence resident and Kansas governor Alf Landon was defeated in a bid for US president, Independence's Republican Party members cast their support for Wendell Willkie, who was no stranger to Montgomery County. Willkie taught school in Coffeyville for one year before returning to his native Indiana to pursue a career in law and politics.

The Independence postal carriers and substitute carriers posing for this 1938 photograph are, from left to right, (first row) Lester E. Perkins, Albert Schoenfeldt, E.R. Benefiel, R.J. Snow (holding National Association of Letter Carriers hat), Frank Harper, and Roy Taylor; (second row) A.W. Cordes, Oscar J. Keltz, Lawrence Turner, E.A. McGuire, Leslie Taylor, and Ted Reeves; (third row) DeVere Dewey, N.L. Barnes, L.V. Ferrell, Edward H. Harper, Harry Robinson, and Walter Maxey.

The Door of Hope Orphanage, located two miles south of Independence on a muddy-looking Tenth Street, was operated by the Bible Holiness Church. Originally a dairy farm, the orphanage was established in 1919 and continued operations until 1971. (Courtesy of Norman Chambers collection.)

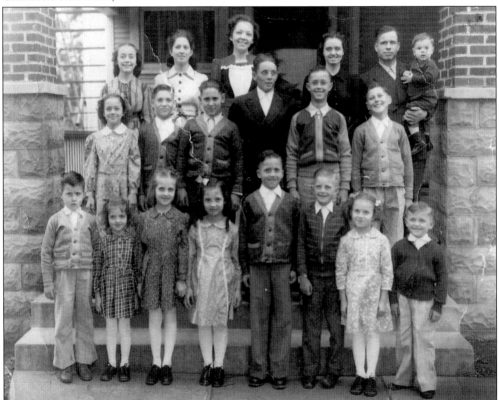

Children and staff of the Door of Hope Orphanage pose in 1940. They are, from left to right, (first row) George Kerr, Kay Livick, Barbara Livick, Dixie Patton, Joe Patton, Ronnie Livick, Helen Rich, and Lee Rich; (second row) Margaret Rich, Jay Rich, Gene Patton, Leo Bales (farm laborer), Lee Rich, and Archie Kerr; (third row) Reba Rich, Frieda Blaes, Audrey Meadows (matron), and orphanage superintendents Eleanor and Everett Chambers (holding infant son Norman). (Courtesy of Norman Chambers collection.)

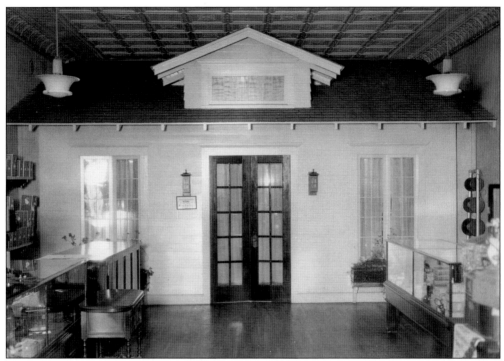

The sales floor of Kansas Gas and Electric Company, at 117 East Main Street, contained a replica house to illustrate the convenience and marvel of modern electricity. W.R. Murrow was the division manager when this photograph was taken in the 1930s. (Courtesy of Westar Energy collection.)

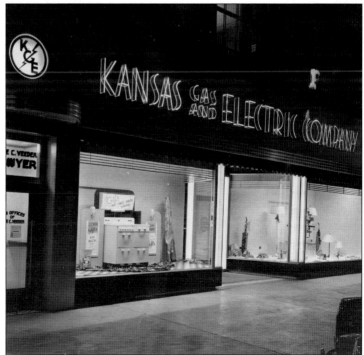

Neon lighting and illuminated store windows electrified the downtown business scene when Kansas Gas and Electric Company, at the 100 block of North Pennsylvania Avenue, unveiled its Christmas merchandise in 1947. Appliances featured in the windows include an electric stove, vacuum cleaner, and table lamps. "Electrical gifts add much to the joy of living," reads one of the promotional materials in the store window. (Courtesy of Westar Energy collection.)

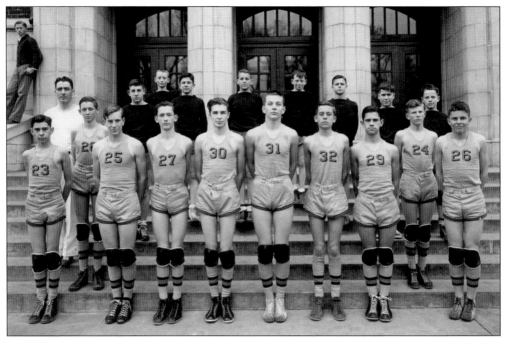

Kneepads and belted shorts were the norm for the Independence Junior High School boys' basketball team in 1944. Posing in front of the school's front entrance are, from left to right, (front row) Larry Rudrauff, Max Barnes, Benny Boswell, Ormond Gillen, Jim Amend, David Graves, Jack Reppert, Jack Sturdivant, Bill Hudson, and Tony Post; (second row) Coach Vincent, Bill Dittmer, Gene Kebert, Jerry Gibson, Buddy Combs, Bobby Dennis, Charles Jardine, Bob Braden, and Jerry Webb.

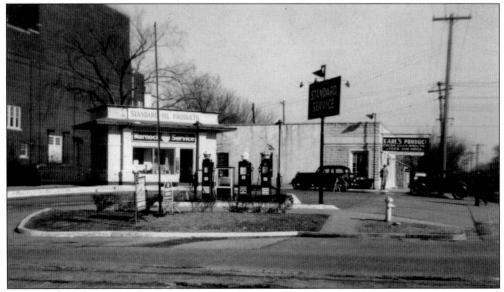

Warnock Service, a vendor of Standard fuel and oil products, occupied a prime location at Pennsylvania Avenue and Chestnut Street when this photograph was taken in the late 1940s. The south portion of Memorial Hall is visible at left. A sign located in front of the store indicates that the street is on US 75 and K 96. (Courtesy of Joe Warnock collection.)

To promote the efficiency of new kitchen ranges, Kansas Gas and Electric Company in Independence created a promotion in April 1950 in which one free ham would be given away to each buyer of a new range. Pictured here are, from left to right, John Tarr, Joe Turner, Jean Reneau, Keith Waddell, and Judy Johnson. (Courtesy of Westar Energy collection.)

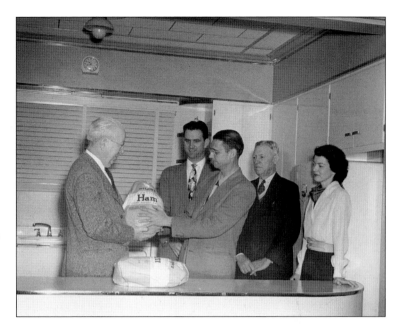

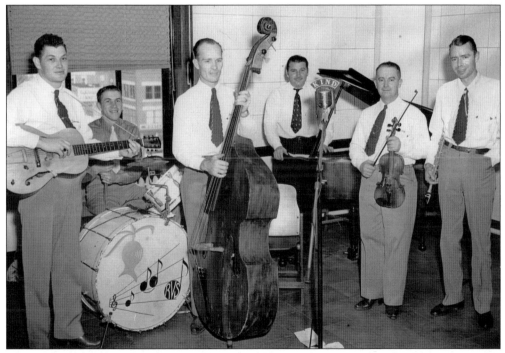

Tommy Ford and the Elk Valley Boys were regulars on radio station KIND in the 1940s. After a short hiatus off the air, the group returned to the airwaves in 1947. "Are we ever glad you are back on the air," wrote a listener from Cherryvale. "Sure did miss you so much. And I do love to hear Bobby play the fiddle and Leon sing. O yes we like the little drummer Randy. Please play and sing 'South of the Border' for about 13 of us. We'll be listening." The letter was signed from "The bunch from Cherryvale."

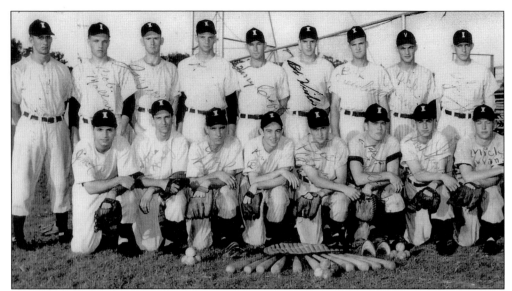

The 1949 season of the Independence Yankees was one of championship and future Hall of Famers. A Class D team in the KOM (Kansas Oklahoma Missouri) League, the Yankees won the league pennant with a 71-53 record. The team included future all-star and Hall of Famer Mickey Mantle (first row, far right) in his first season in the professional ranks. Shown here are, from left to right, (first row) Jim Bello, Steve Kraly, Charlie Weber, Ken Bennett, Bill Chambers, Jack Whitaker, Lou Skizas, and Mantle; (second row) John Cimino, Bob Mallon, Joe Crowder, Keith Speck, Harry Craft (manager), Bob Wiesler, Bobby Gene Newbill, Nick Ananias, and Al Long. From this group, Kraly, Skizas, Mantle, and Wiesler would play in the major leagues.

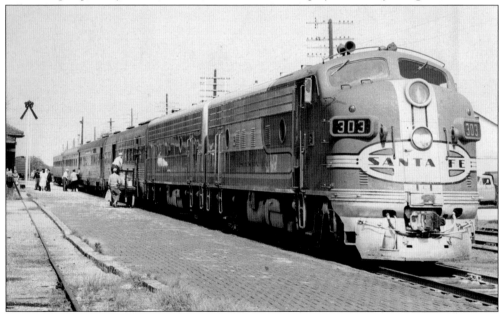

The *Oil Flyer*, the daily Santa Fe passenger train that traveled from Tulsa to Kansas City, Missouri, paused momentarily at the Santa Fe depot in Independence when this photograph was taken in 1950. The final passenger train would travel through Independence in 1970. (Courtesy of Ned Stichman collection.)

Glenn Connelly, a co-owner of the Tribune Printing Company, pauses for a photograph in the 1950s. The Tribune Printing Company was a fixture of the Independence business scene for many decades. (Courtesy of John Koschin collection.)

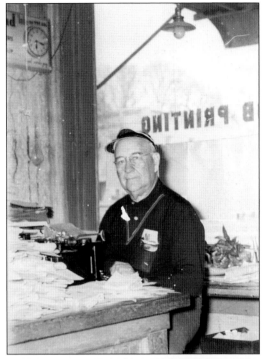

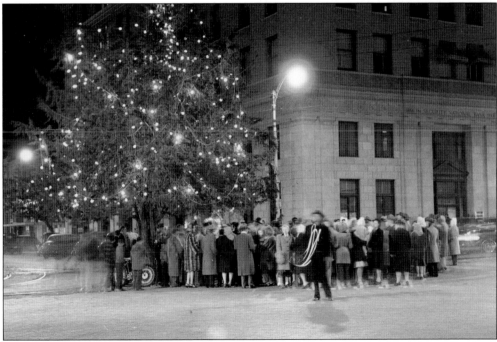

New streetlights in downtown Independence made for brighter illumination of the Christmas parade on December 4, 1948. A group of shoppers gathers at the community Christmas tree at the intersection of Pennsylvania Avenue and Myrtle Street, and a police officer guides traffic. This photograph was taken with a timed exposure, as indicated by the movement of the crossing guard's light and the movement of the pedestrians. (Courtesy of Westar Energy collection.)

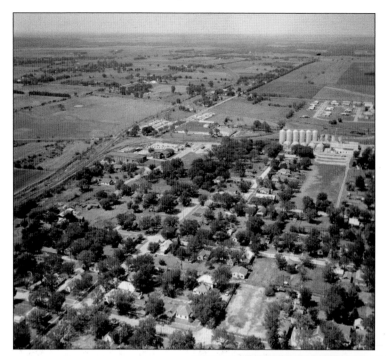

The junction of the Missouri Pacific (now Union Pacific) and Santa Fe Railroads can be seen in this aerial photograph of Independence's industries in the town's northwestern corner. The 1950s image faces northwest. The first hint of the "suburbs" can be seen in the upper-right corner. The new homes were built on what is now North Seventeenth Place, North Eighteenth Place, and Circle Drive. (Courtesy of Westar Energy collection.)

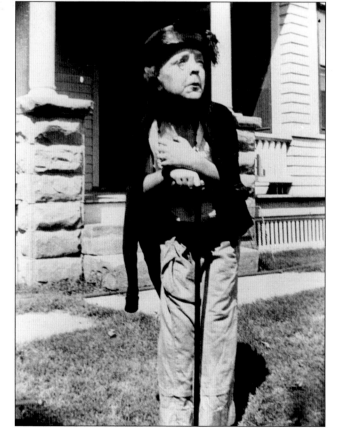

Billy Inge had a flair for theatrics as a young child. Growing up in his home at 514 North Fourth Street, William Inge, as he would come to be known, entertained his neighborhood friends by dressing up in costumes and assuming different characters, as seen here in his characterization of an old lady. (Courtesy of the Inge Collection at the Independence Community College Library.)

Pulitzer Prize–winning playwright and Independence native William Inge (right) returned to his hometown at the peak of his career in 1958, where he was inducted as an honorary member into the Independence High School Drama Club. While visiting his alma mater, Inge was presented with a ticket to a school play from IHS Drama Club member and IHS senior Bill "Horton" Kurtis. The photograph is noteworthy, as it shows two Independence natives who would find great acclaim in the entertainment and news industries. Inge was revered in theatre circles, and Kurtis would go on to become a nationally acclaimed reporter for CBS News as well as a television documentary producer. (Courtesy of the Inge Collection at the Independence Community College Library.)

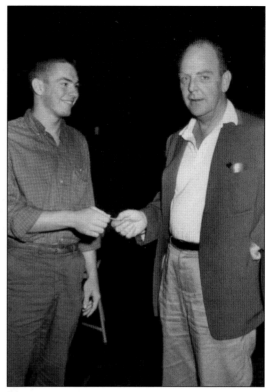

Independence High School football coach Walter "Kayo" Emmot had a strong influence on athletics in the community. During his years as head coach (1954–1967), Emmot led the Bulldogs through a string of 49 consecutive victories that spanned the years 1957 to 1962. He coached at Independence Community Junior College from 1968 to 1970. Emmot died in 1996, and a statute bearing his likeness was installed outside the main gate of Shulthis Stadium in 2010. (Courtesy of Ray Emmot collection.)

Jim Oliver, a Union Gas Systems employee in Independence, braves the snowy conditions in February 1951 to set a residential gas meter. Chains are applied to the Ford truck's tires.

Harrison Johnson, president of the Independence-based Union Gas Systems, presents certificate awards to employees Louise McPheeters (left), Sally Walker (second from right), and Pearl Grabham in this 1960s photograph.

In 1966, the Independence Community Theatre production of the comedy *Mary, Mary* was performed for two nights at Memorial Hall. This publicity photograph shows, from left to right, George Butler, Jo Woods, Don Dancer, and Roy Klippenstein. (Courtesy of the Independence Public Library collection.)

Kansas attorney general William Ferguson meets with members of the Obscene Literature Committee of the Independence Women Federated Clubs in February 1964. Ferguson asked organizations across Kansas to assist in his effort to reduce or eliminate magazines that he considered harmful to the morals and character of Kansans.

Independence postal carriers pose for a photograph in 1964. They are, from left to right, Wilbur Olsen, Don Maugans, Delmar Jones, John Salisbury, Floyd Speights, Basil Post, Robert Frisco, Robert Wesley, Carl Alexander, Marshall Albers, and Bob Silger. The Independence Post Office had moved into its new location at the corner of Sixth and Laurel Streets just two years earlier.

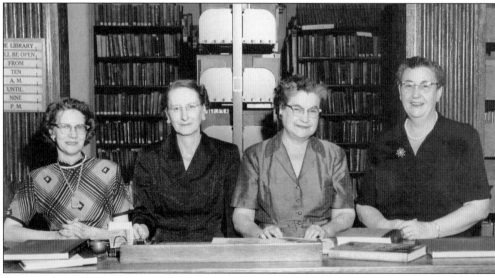

Seen in the mid-1960s, past and current employees of the Independence Public Library have gathered for a photograph. They are, from left to right, Rita Cooper, children's librarian; Mildred Holt; Mabelle Bays, librarian from 1936 to 1965; and Margueritte Rockwell, who served from 1965 to 1968. (Courtesy of the Independence Public Library collection.)

The development of the Little House on the Prairie Museum can be credited to the involvement of William and Wilma Kurtis, seen here in 1983. The museum site opened to the public in 1977. (Courtesy of *Montgomery County Chronicle* archives.)

The Little House on the Prairie Museum, which opened in 1977, includes a replica log cabin that was described in Laura Ingalls Wilder's novel *Little House on the Prairie*. The grounds of the pioneer museum also include the former Wayside Post Office and the Sunnyside School. Pioneer lifestyles and old-fashioned arts and crafts are celebrated at the site each year, as illustrated by this 1983 celebration. (Courtesy of Westar Energy collection.)

Independence Community College art teacher Leonard Wood (right) guides an ICC student on a pottery wheel in this c. 1978 photograph. Wood, a rural Cherryvale resident, taught art classes at ICC throughout the 1970s and 1980s. (Courtesy of Independence Community College collection.)

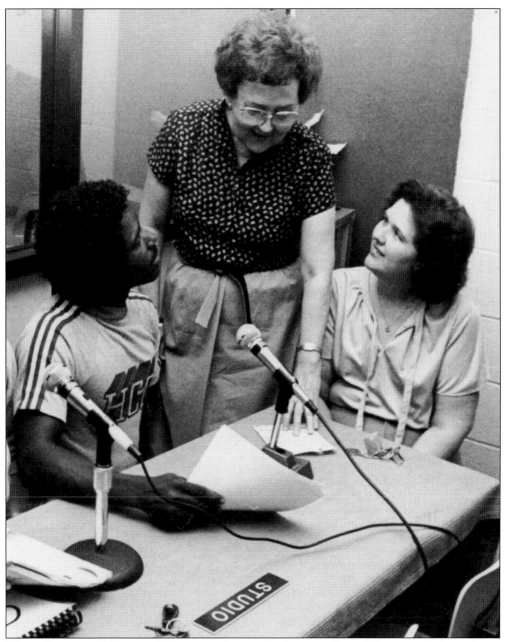

The influence of Margaret Goheen, professor of radio, speech, and drama at Independence Community College, was felt for many years. Her devotion to theatre led her to organize the first William Inge Theatre Festival in 1982. Her name is displayed in the foyer outside the Inge Theatre on the college campus. In this c. 1980 photograph, Goheen is at center. (Courtesy of Independence Community College collection.)

J. Nelson Rupard was a one-man news department, toting his KIND radio equipment from one locale to another. The owner of radio stations KIND-AM and FM was a veteran newsman whenever he picked up the microphone, as is evident in this 1996 photograph, in which he reads election results from the foyer of the Montgomery County Courthouse. Rupard, who established KIND in 1947, died doing the very thing he loved best: broadcasting. He passed away on his 88th birthday while doing a live broadcast of Broadway and jazz hits. (Courtesy of the *Montgomery County Chronicle* archives.)

Seven

SOUVENIRS

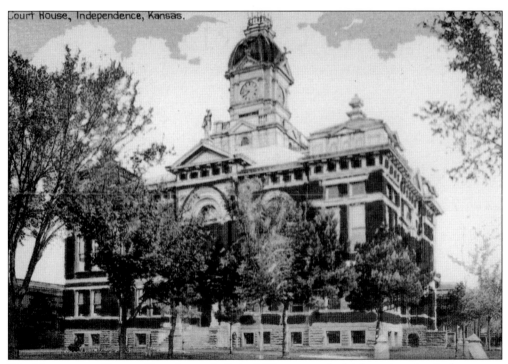

Court House, Independence, Kansas.

The Montgomery County Courthouse, built in 1887, sat atop the highest elevation in downtown Montgomery County and had a roofline that made it stand out among all other buildings in the community. Complete with a clock tower and multiple architectural elements, including a statue of Justice above the front entrance, the courthouse was constructed for $58,200. "As a whole, the Montgomery County Court house [*sic*] is a model building, substantially built of the best material, well designed and built in a first class manner," wrote the *South Kansas Tribune* in a souvenir issue in December 1887 to commemorate the building's dedication. (Courtesy of Rick Knapp collection.)

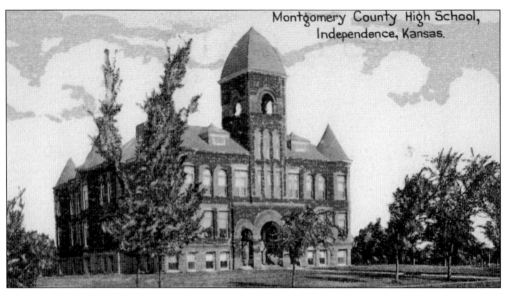

Montgomery County High School, built on the block west of Tenth Street and north of Chestnut Street, opened in 1899 amid controversy in some quarters of the county. After the Kansas Legislature approved a bill to authorize the new county high school in 1897, opponents within Montgomery County gained an injunction in district court to stop the levying of a countywide tax for the school's construction. The litigation reached the Kansas Supreme Court, which, on May 7, 1897, dissolved the injunction and allowed construction to commence. Ground was broken on June 20, 1898. The school opened its doors to students on September 4, 1899. (Courtesy of Rick Knapp collection.)

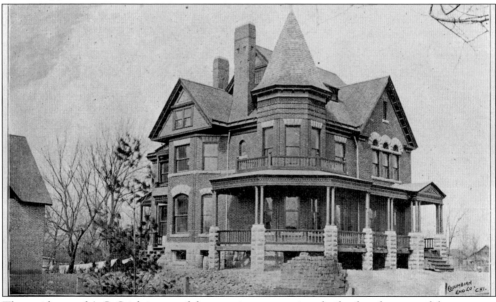

The residence of A.C. Stich is one of the prominent mansions built after the turn of the century. Located at 203 South Fifth Street, the mansion and its owner were described by the *Independence Weekly Times* in a 1907 souvenir issue: "Lavish hospitality, making the guests of the city his [Stich's] own and doing all in his power to send them away with a good impression of the city, its people, its industries and its future." (Courtesy of Ken Brown collection.)

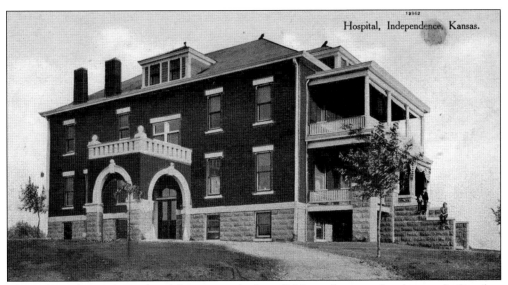

The Independence Hospital and Sanitarium, built in 1906, was "equipped with every facility that modern science can suggest for the care of medical and surgical cases," stated the *Independence Weekly Times* in a 1907 souvenir issue. The hospital was located at the corner of Fifth and Stephenson Streets. (Courtesy of Ken Brown collection.)

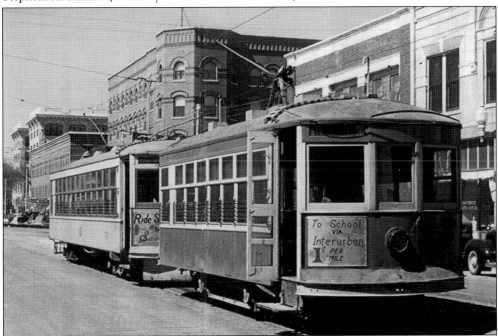

"Ding, ding, ding, went the trolley" was the popular line from the musical *Meet Me in St. Louis.* However, that same lyrical line could also be heard in Independence, where the Union Electric Traction Company provided hourly transports along its route, which stretched from Parsons, Kansas, to Nowata, Oklahoma. Independence was in the middle of that line, and the trolley cars serviced businesses in the downtown business district. This photograph was taken at the 100 block of West Myrtle Street. The Carl-Leon Hotel and the Prairie Oil and Gas Company headquarters are visible in the background. (Courtesy of John Koschin collection.)

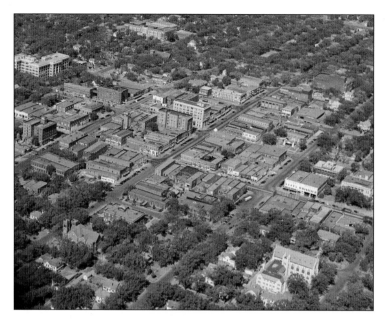

This aerial photograph of downtown Independence is believed to have been taken in the 1950s. The First Presbyterian Church is located in the lower-right corner, and the Independence Middle School is located in the top center. This view looks toward the northwest. (Courtesy of Ned Stichman collection.)

Baseball was the sport of choice in early Independence, as is evident by this 1896 photograph of a local team. The players, identified only by their last names, are, from left to right, (first row) Conlen, Jones, and Hiss; (second row) Franie, Drummy, Jones, and Hulbert; (third row) Colborn, Goodell, Oswald, and Underwood. (Courtesy of Mark Metcalf collection.)

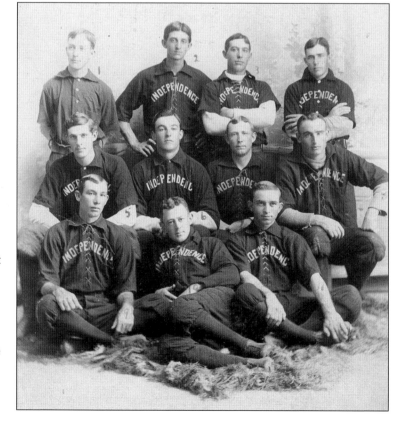

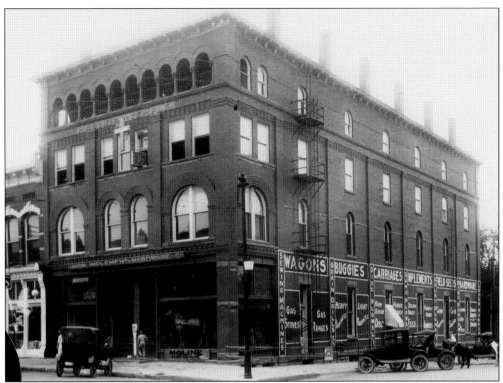

The Union Implement Building, at the corner of Eighth and Main Streets, has been one of the dominant structures of the downtown Independence landscape. The massive building, topped with a two-story Masonic lodge, was one of the largest agriculture-implement and agricultural supply stores in southeast Kansas. The store carried everything from whips to windmills. (Courtesy of Ken Brown collection.)

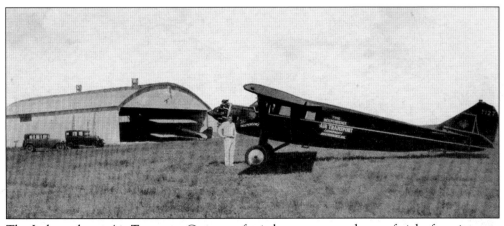

The Independence Air Transport Company ferried passengers and some freight from its grass runway at the airport, located on the grounds of the present-day Sycamore Valley Country Club, south of Sycamore. (Courtesy of Rick Knapp collection.)

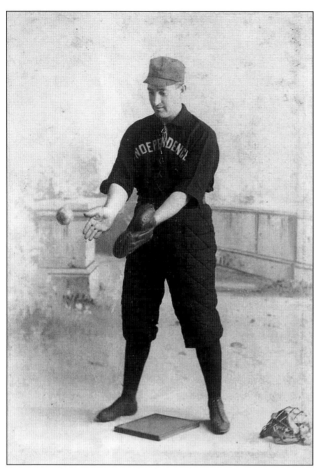

This unidentified player for an early Independence baseball team had enough money to afford a portrait from the Albert Brown Studio in Independence. Note the catcher's mask on the ground. The photograph is believed to have been taken in 1896.

Flags fly briskly atop downtown Independence's tallest structures in this 1920s postcard photograph. The Union Traction trolley line ran through the middle of Pennsylvania Avenue.

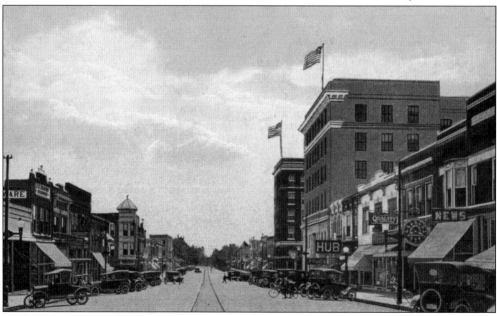

With a massive round turret topped with a conical roof, the building that was originally the State Bank of Commerce later became the New York Candy Kitchen. The building, erected in 1908, was located on the site of the present-day Community National Bank drive-thru facility on the southeast corner of Pennsylvania Avenue and Myrtle Street. (Courtesy of John Koschin collection.)

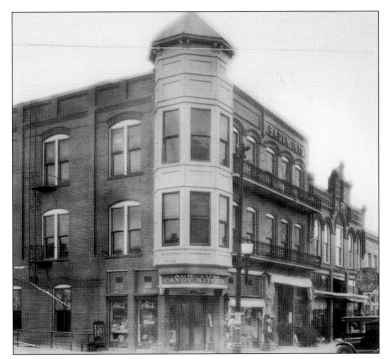

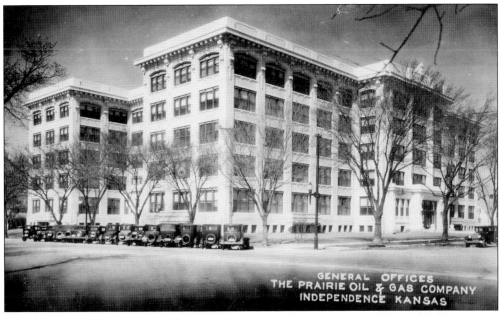

The headquarters of the Prairie Oil and Gas Company was considered a "skyscraper."

The Stich Shelter House and Sunken Garden at Riverside Park in Independence is depicted in a postcard dated about 1920. (Courtesy of Rick Knapp collection.)

LEGION VILLE HOME, INDEPENDENCE, KANSAS

Legionville, a home for orphaned children of soldiers killed in World War I, was located 11 miles south of Independence. Operated by the American Legion Auxiliary and Kansas American Legion, Legionville was a 388-acre farm that could accommodate up to 50 children. The State of Kansas took over operations in 1931 and converted the facility into a preventorium for children who were malnourished or had been exposed to communicable diseases. The facility closed its doors in 1941. (Courtesy of Rick Knapp collection.)

NEW MEMORIAL BUILDING, INDEPENDENCE, KANSAS.

Memorial Hall, which opened its doors in 1924, has been the entertainment center for the Independence community, hosting everything from school graduations to dance recitals to queen competitions. Among the biggest names to appear in the hall in its early years was humorist Will Rogers, who spoke on November 15, 1926. After the show, Rogers spoke backstage in a special link from NBC Radio, marking the first time that network had a coast-to-coast live broadcast. (Courtesy of Rick Knapp collection.)

CITY HALL,
INDEPENDENCE, KANS.

Independence City Hall, located at Sixth and Myrtle Streets, was the center for all municipal services. It had the rare distinction of being among the few municipal buildings in which administrative offices, the courts, and fire and police functions were under one roof. (Courtesy of Rick Knapp collection.)

The downtown Independence streetscape of the 1950s and 1960s slowly began to change. The brick facades with their turn-of-the-century architectural styles were giving way to faux metal fronts, much like the one that covers the front of the Independence State Bank (left) on the 100 block of North Pennsylvania Avenue. (Courtesy of Rick Knapp collection.)

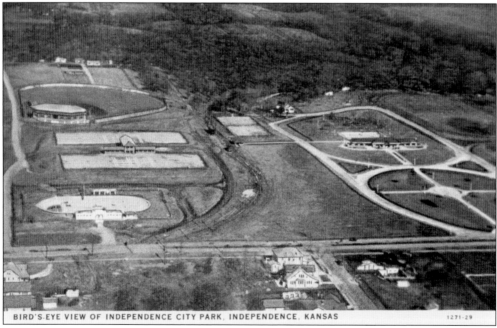

BIRD'S-EYE VIEW OF INDEPENDENCE CITY PARK, INDEPENDENCE, KANSAS 1271-29

This bird's-eye view of Riverside Park shows the numerous tennis courts, Shulthis Stadium, the Stich Shelter House, and the sidewalks lining the area in front of the shelter house. The Union Electric trolley system cut through the park; its tracks are evident to the right of the tennis courts. (Courtesy of Rick Knapp collection.)

126

BIBLIOGRAPHY

Army and Navy Publishing Company of Louisiana, Independence Army Flying School, 1944.

Brown, Ken. *A Guide to Historic Homes in Independence, Kansas.* Self-published, 1993.

Connelly, William E. *A Standard History of Kansas and Kansans.* Lewis Publishing Company, Chicago: 1919.

Duncan, L. Wallace. *History of Montgomery County, Kansas by Its Own People.* Iola, KS: *Iola Register,* 1903.

Harper, Paul Franklin. *Pashe to Wah, "Bred and Pize for Saile Hwer": A History, Atlas, Index and Description of Montgomery County, Kansas, to 1880.* Self-published, 1883.

History and Families of Montgomery County, Kansas. Nashville, TN: Turner Publishing Company, 1995.

Kansas State Board of Agriculture First Biennial Report to the Legislature of the State of Kansas for the years 1877–78.

Koschin, John. *Independence: Then and Now.* Self-published, 2008.

———. *Independence: More Then and Now.* Self-published, 2011.

———. *Neewollah: The Early Years, 1919–1949.* Self-published, 2011.

Sherwood, Leon A. Sr. *Independence Centennial Official History: The Spirit of Independence.* Independence, KS: Montgomery County Historical Society, 1970.

Young, H.W. and Sons. *Independence: Heart of the Kansas Gas and Oil Field.* Independence, KS: *Independence Weekly Times,* 1907.

Wilson, Ebenezer E. *Historical Atlas of Montgomery County, Kansas.* Philadelphia, PA: John P. Edwards, 1881.

DISCOVER THOUSANDS OF LOCAL HISTORY BOOKS
FEATURING MILLIONS OF VINTAGE IMAGES

Arcadia Publishing, the leading local history publisher in the United States, is committed to making history accessible and meaningful through publishing books that celebrate and preserve the heritage of America's people and places.

Find more books like this at
www.arcadiapublishing.com

Search for your hometown history, your old stomping grounds, and even your favorite sports team.